CLARITY

A PHOTOGRAPHIC DIVE INTO LAKE TAHOE'S REMARKABLE WATER

Dylan Silver

SCHIFFER
PUBLISHING

4880 Lower Valley Road • Atglen, PA 19310

Designed by Ashley Millhouse
Cover design by Ashley Millhouse
Type set in Aviano Sans/Adobe Caslon Pro
ISBN: 978-0-7643-5944-6
Printed in China

Published by Schiffer Publishing, Ltd.
4880 Lower Valley Road
Atglen, PA 19310
Phone: (610) 593-1777; Fax: (610) 593-2002
E-mail: Info@schifferbooks.com
Web: www.schifferbooks.com

For our complete selection of fine books on this and related subjects, please visit our website at www.schifferbooks.com. You may also write for a free catalog.

Schiffer Publishing's titles are available at special discounts for bulk purchases for sales promotions or premiums. Special editions, including personalized covers, corporate imprints, and excerpts, can be created in large quantities for special needs. For more information, contact the publisher.

OTHER SCHIFFER BOOKS ON RELATED SUBJECTS

Archipelago New York, Thomas Halaczinsky, ISBN 978-0-7643-5507-3

Art from above Cape Cod, Christopher S. Gibbs, ISBN 978-0-7643-5747-3

Chesapeake Waters: Four Centuries of Controversy, Concern, and Legislation, Steven G. Davison et al., ISBN 978-0-87033-501-3

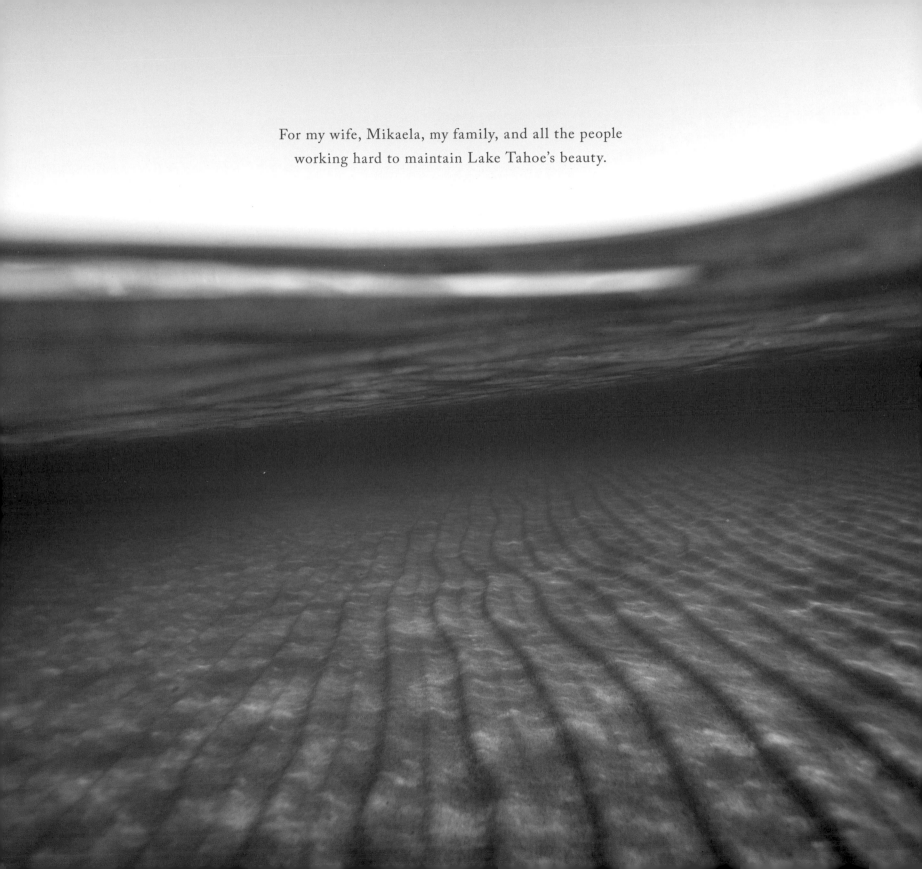

For my wife, Mikaela, my family, and all the people
working hard to maintain Lake Tahoe's beauty.

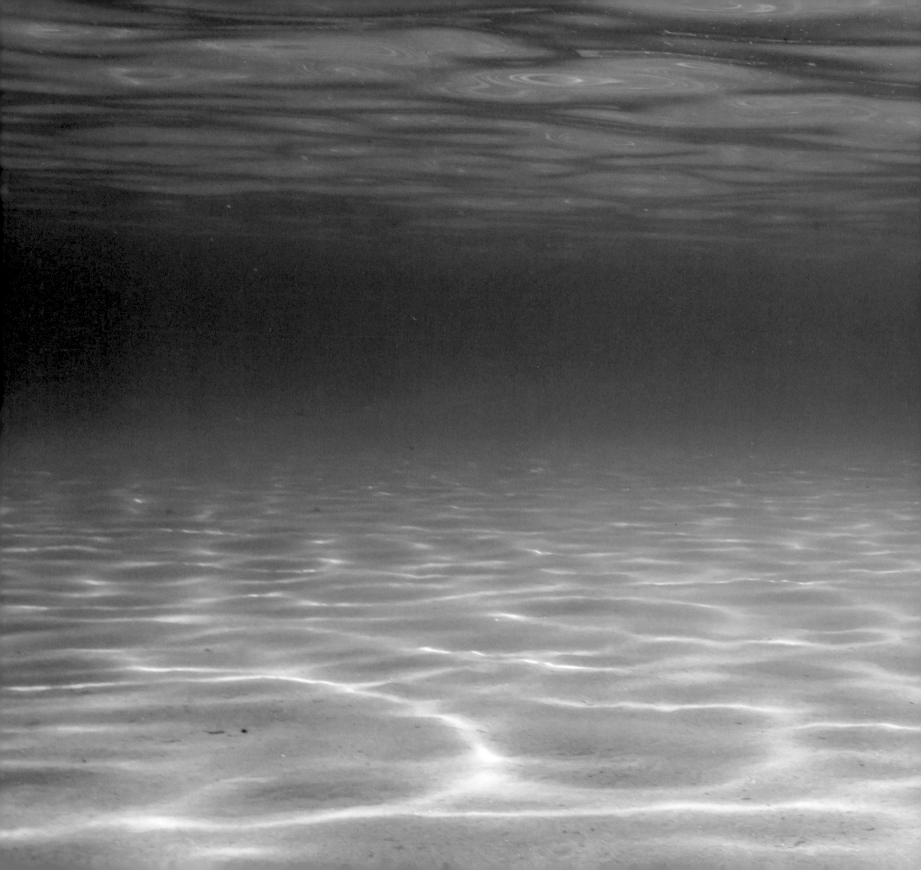

> " "
>
> Down through the
> transparency of these great
> depths, the water was not
> *merely* transparent,
> but dazzlingly, brilliantly so.
>
> —Mark Twain, *Roughing It*, 1872
>
> " "

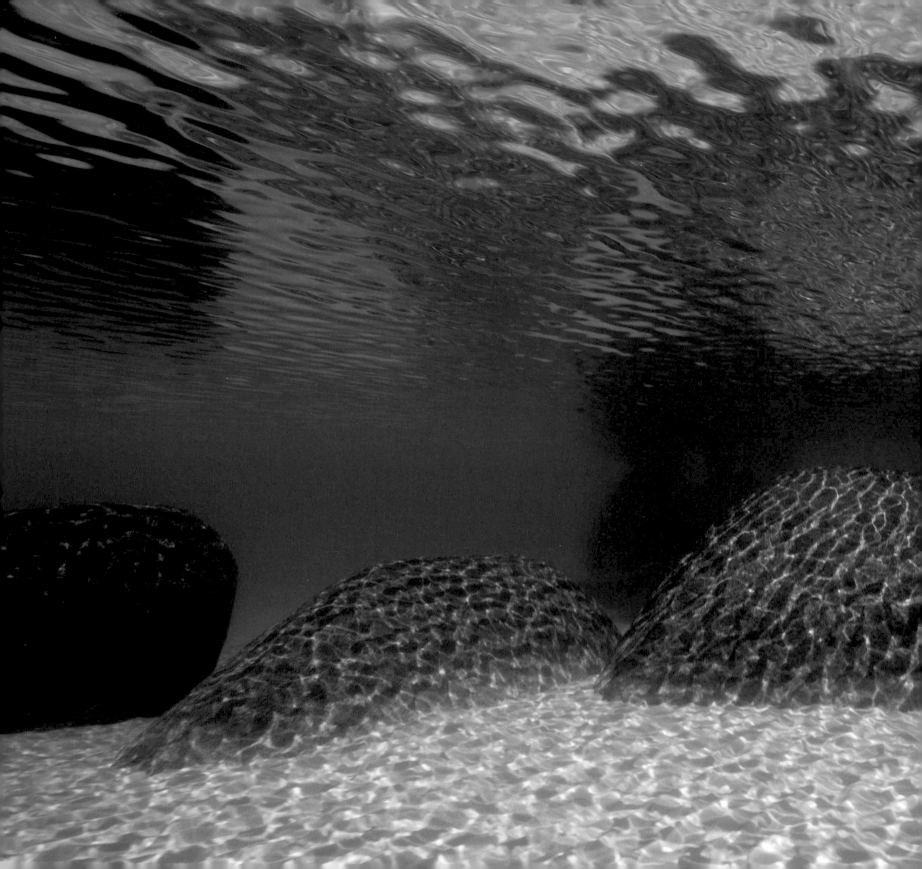

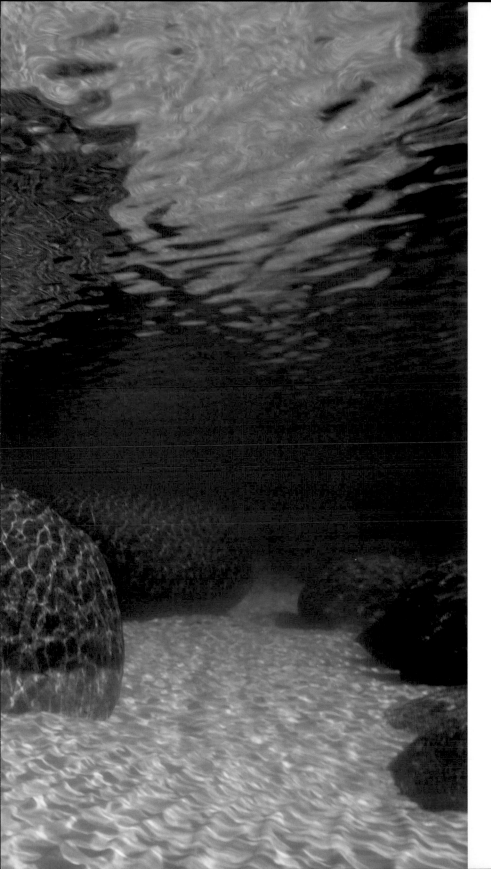

CONTENTS

FOREWORD

Lake Tahoe is a stunning place. It's the kind of landmark that the world pays attention to. The area has hosted presidents and international leaders. It has inspired great American writers and artists. The crystal blue waters and granite peaks of the Lake Tahoe Basin have entertained and awed generations of visitors and residents.

All of us raised at Tahoe grew up with a sense of the lake's scale and power, and we respected it. But as kids, we could take it for granted. It was our backyard playground. It wasn't until I had a high school internship with the League to Save Lake Tahoe—the organization that started the Keep Tahoe Blue movement—that my outlook changed.

I learned that Lake Tahoe is fragile. It is famous for its clear water, which has been monitored consistently since the late 1960s. Measured first at over 100 feet deep, the clarity has now dropped to an annual average of around 70 feet. The League and other conservation organizations have had to continually ward off threats that would further impact the signature blue water.

When I interned for the League during the summers of 1996 and 1997, I got a firsthand look at just how important Lake Tahoe is to the nation. That second summer, we spent much of the time preparing for the arrival of President Clinton and Vice President Gore for the first Lake Tahoe Summit. The stakes were high in those years. The annual lake clarity hit a new low, and the long-term trend was dim.

I look back to that summer as the turning point when I realized that the Lake Tahoe we knew would not be here for us in the future unless people like me got more involved. It takes a personal commitment from many people to advance the political dynamics that result in lasting environmental protections.

All these years later, I am fortunate to be running the same organization where I was once a high school intern. But the stakes have only gotten higher. While the overall decline in the lake's deepwater clarity appears to have been arrested, we still have bad years. In 2017, when many of the images in this book were shot, average annual clarity dropped to 60 feet, a new low. Fortunately, clarity rebounded to 70 feet in 2018.

The historic threats to Lake Tahoe's clarity remain, such as urban stormwater runoff from roads and the destruction of the wetlands and meadows that serve as natural pollution filters for the lake. Climate change poses new complexities: more frequent intense storms that can worsen stormwater pollution, and warming lake water that is more hospitable to aquatic invasive species, which also degrade clarity. Researchers expect climate change to create larger swings in clarity from year to year.

I still have hope. Since 1997, the League has advocated for hundreds of millions of dollars for public agencies to conduct environmental restoration at Lake Tahoe. We have engaged thousands of volunteers to participate in cleanups, hands-on restoration efforts, and citizen science programs to address the threats of stormwater pollution and aquatic invasive species. And, more than ever, a new era of public-private collaboration at Tahoe has helped advance stronger protections for the lake we all love.

Throughout this effort, photographers have played a special role. At the League, we use photos to draw people to our cause. They illustrate our reports, encourage people to donate on social media, and remind our staff what we're working for daily. We have every interest in showing the stunning beauty of the area, with no filters. Our hope is that the photographs on the following pages—the largest collection of underwater images of Lake Tahoe ever published—will motivate readers to protect the clear, cold waters we love.

While the threats are dire, it's far from too late for Lake Tahoe, as long as people get involved. There's a role for everyone. You can take personal action to cut pollution by biking or walking instead of driving to the lake. You can roll up your sleeves and volunteer with the League. You can use your voice to tell your public officials to make restoration of the Lake Tahoe Basin a top priority.

Lake Tahoe can't protect itself, but together we can protect its clarity. Please help Keep Tahoe Blue and enjoy this visual reminder of why this is such a special place.

—Darcie Goodman Collins, Chief Executive Officer, League to Save Lake Tahoe

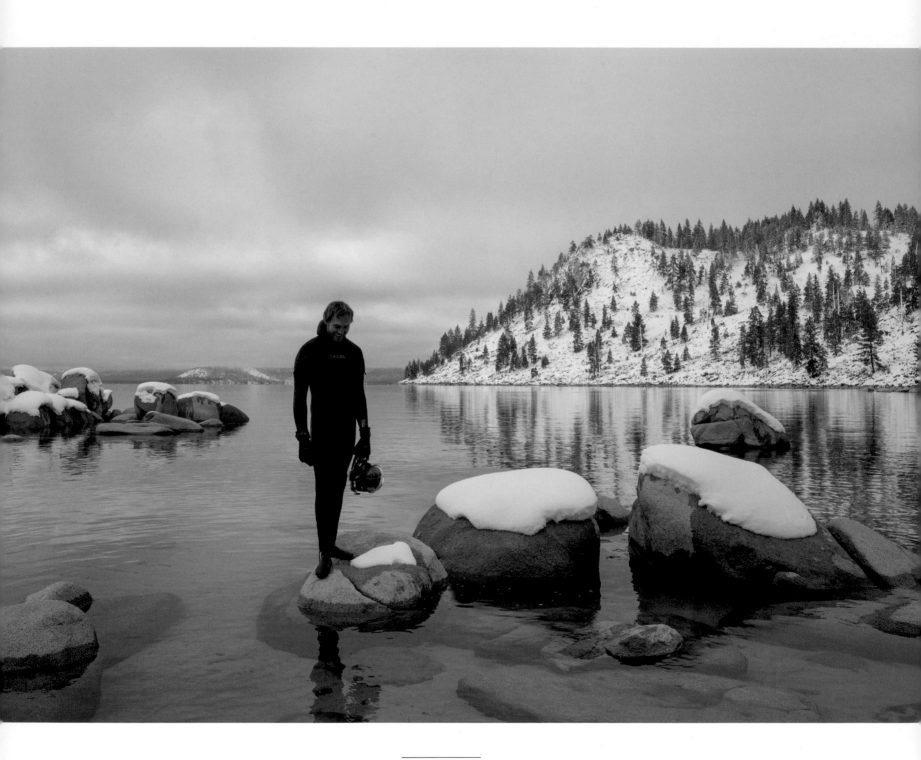

INTRODUCTION

There was a moment one winter when I wondered if I'd taken this idea too far. I was on the East Shore, near Cave Rock. Snow was coming down in drifts. I had my thickest wetsuit on, with the hood pulled tight around my chin. But I couldn't get to the lake. Snowbanks blocked my usual path. The parking lot was closed.

I knocked on the door of a nearby lakefront house. An older woman opened. I asked if I could walk through her yard so I could go swimming.

"Swimming?" she said, puzzled. "Are you crazy?"

For the last five years, I wandered to the edge of Lake Tahoe and jumped in to take photos. I collected tens of thousands of images from all sides of the lake. I swam in storms and on days when the surface was so calm it mirrored the sky. I watched waves heave onto the rocky shore and steam rise on cold summer mornings. I saw the water move and change, break and reform.

I've loved Lake Tahoe since I first visited at age eight with my parents. I still remember my first forays into its depths, dropping over the side of my rubber raft with a heavy rock. I stood on the bottom with my tiny goggles, peering into the teal until my lungs felt like they would explode. Since those first trips to Sand Harbor, I've gone swimming every chance I could get. When I took up photography in my twenties, I already knew the stunning beauty that was just under the surface.

As a writer and photographer for the *Tahoe Daily Tribune*, I learned a lot about the lake's history and the tumultuous fight to "Keep Tahoe Blue." The more I heard about the water, the more surprised I was to find so few pictures of the spectacular clarity that Mark Twain described as brilliant and dazzling. I believe that if you can show people beauty and rarity, they will move to protect it. Rather than lecture and demand, I wanted to remind those who love Lake Tahoe of what they stand to lose. More than numbers and statistics, there's no better reminder than the water itself.

I did not set out to photograph every Lake Tahoe beach or historical marker. The intent wasn't to document the best swimming spots or create a guide to the shoreline. I simply wanted to shoot images of what the water looks like and capture the feeling of being submerged in its turquoise-and-blue grace.

I tried to picture Lake Tahoe in all its moods. I photographed during every month of the year, morning, afternoon, and occasionally at night. The water transforms with the angle of the sun. Rays and beams shoot through the surface at dawn and dusk. In the afternoons, bright patterns and dark shadows play off the bottom. Every movement of the water changes the effect. If the Sierra Nevada is the Range of Light, Lake Tahoe is definitely the Lake of Light.

To make this series of images, I used a DSLR in a waterproof housing. I opted to avoid artificial lighting except in a few instances to illuminate subjects that weren't otherwise photographable, or sometimes to make an effect. I used minimal editing to maintain an accurate representation of the water. Usually, changes to images were applied broadly across the whole image. Very few spot edits or changes to overall color or tone were made. Every once in a while, I removed spots that resulted from a dirty camera sensor.

Lake Tahoe has a calming effect on me. When I'm in the water, my heartbeat and pulse tend to slow. And I get cold easily. When swimming or diving, I am almost always in a wetsuit. In the winter, I used 9 mm of neoprene. This usually allowed an hour or so of swimming in snowy conditions. The summer was easier and often required only a ¾ mm suit. To counter the buoyancy of the rubber, I used a weight belt and fins. My trusty old Oceanic mask gave me a window to see underwater. The rest was up to the lake, which constantly surprised me with character of its own.

Lake Tahoe is more than two million years old. Humans have been there to witness only a fraction of its life. Every drop of rain or snow

that falls in the Basin and makes it into the lake stays for 650 to 700 years before evaporating or flowing down the only outlet, the Truckee River. I thought about this while I was swimming. The same water that I splashed around in was there when the Civil War was taking place. The same waves were breaking when the Washoe were spending summers along the shore. The lake has hosted so much history. But our interactions have taken a toll.

We know that the water's clarity took a big hit when much of the Lake Tahoe Basin was clear-cut in the early twentieth century. Some of the tributaries were dredged and straightened for industrial purposes. The marshes and meadows that filtered water coming into the lake were built over or destroyed by livestock grazing. This gave sediment a free ride into the lake. We don't know how clear Lake Tahoe might be were it not for this development. In 1968, the first year of measurement, the clarity averaged 102.4 feet.

In an unfortunate coincidence, Lake Tahoe experienced its worst year of clarity while I was making many of the images in this book. In 2017, clarity fell to an average of 59.7 feet. This was all too obvious below the surface. What was once sharp definition in the granite became hazy shapes in a green-blue dusk. The influx of particulate could be seen from the surface. The dark-blue hue along the shoreline at D. L. Bliss State Park morphed into a deep green. At 80 feet, there was a persistent fog. For an underwater photographer who wanted to capture Lake Tahoe's beauty, it was frustrating and sad. But I tried to show what some of those scenes looked like with the hope that we could avoid this in the future.

I've loved documenting the color, the movement, and the things I've found underwater in Lake Tahoe. And I enjoy sharing my images. But more than anything, I embarked on this project for other, more selfish reasons. Being in the water is purely therapeutic. It's an escape from the pressures of life. It's quiet. It's time when I can think and move freely. In the teal shallows along the edge of the lake, there are no phone calls or internet or insurance. There are no crowds (except in a few places). There's nothing but me and my camera and the light flitting through the waves. Crazy or not, swimming in Tahoe's cold, clear water is the best feeling in the world. I hope *Clarity* evokes, at least in a small way, this same feeling for others.

Lake Tahoe is more than
two million years old.
Humans have been there
to witness only a fraction
of its life.

WATER, LIGHT, STONE

The day after I received my first underwater camera housing in the mail in late 2014, I waded into the shallows to shoot. It was snowing and cold, and I had my waders on. I remember bringing the LCD screen up and peering for the first time at the photos I'd made. I was instantly fascinated by the color and texture of the crystal grains of sand. That year, I spent more than sixty days in the lake with my clunky red camera and big acrylic dome.

The images in this chapter represent hundreds of hours in the water. This series as a whole is meant to convey what I love most about Lake Tahoe: the teals, the blues, the arrangement of the rocks on the bottom, and the patterns of the light that brighten and darken the textures.

Many people find joy in the empty shorelines, the mountains ringing the Basin, the crash and splash of big waves and small ripples, the sun and the storms. I wanted to show how all these elements come together to create this special place. I found that images without people or man-made landmarks show how timeless Tahoe is. It's the way I tend to think of the lake when I'm daydreaming about swimming.

Underwater photography is tricky. It's a combination of challenges, from equipment to technique, water conditions to lighting. I found inspiration in many other photographers' work. Water, Light, Stone is a nod to the work of David Doubilet, whose book *Water, Light, Time* is one of the greatest underwater photography books ever published.

Though Lake Tahoe isn't filled with exotic life, there is no shortage of interesting shapes, vivid colors, textures, and resplendent light. For years, the sand, boulders, and beams have been my temple. It's where I've gone to enjoy just being alive in a beautiful place.

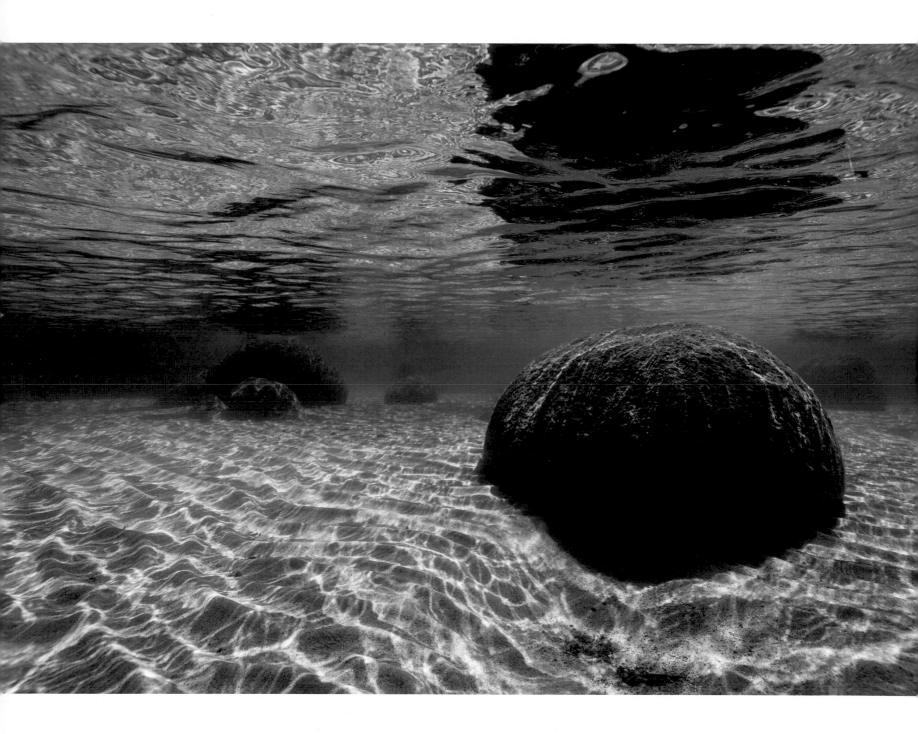

CLARITY

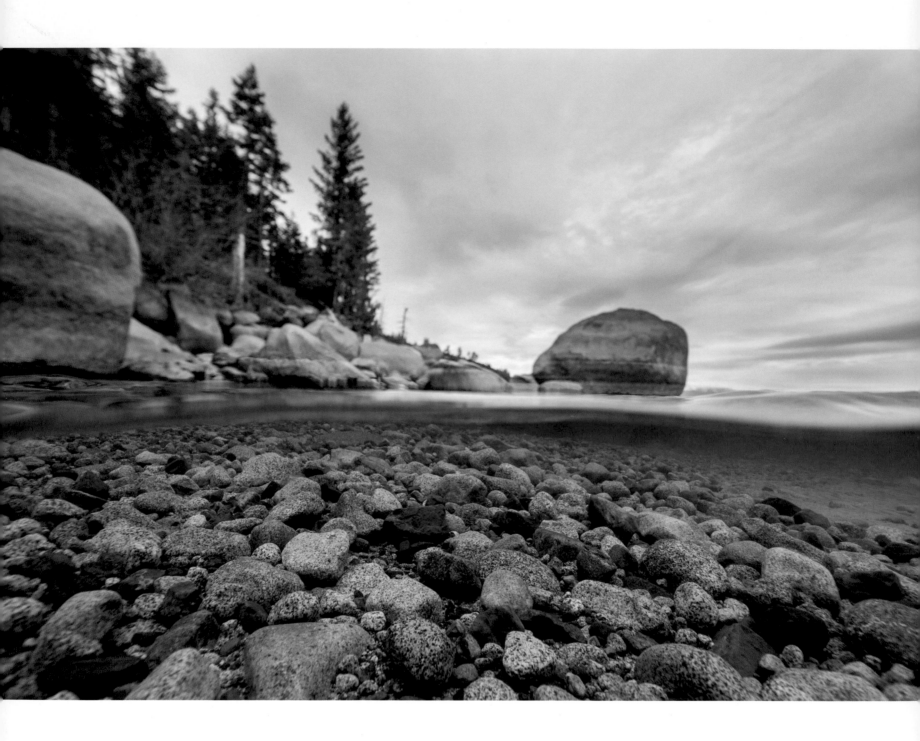

CLARITY

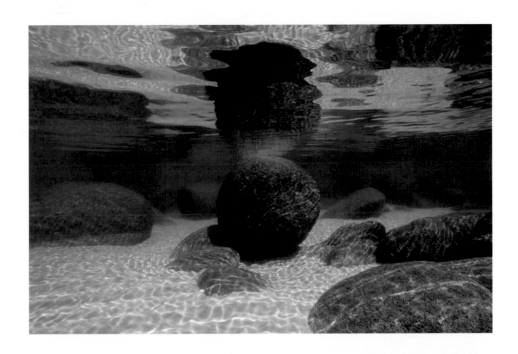

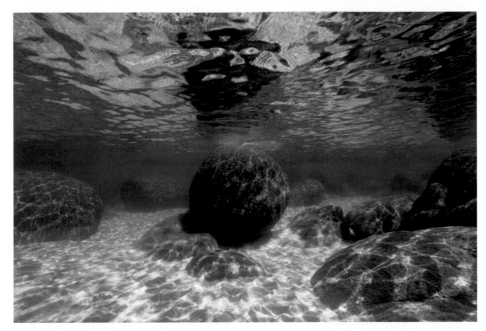

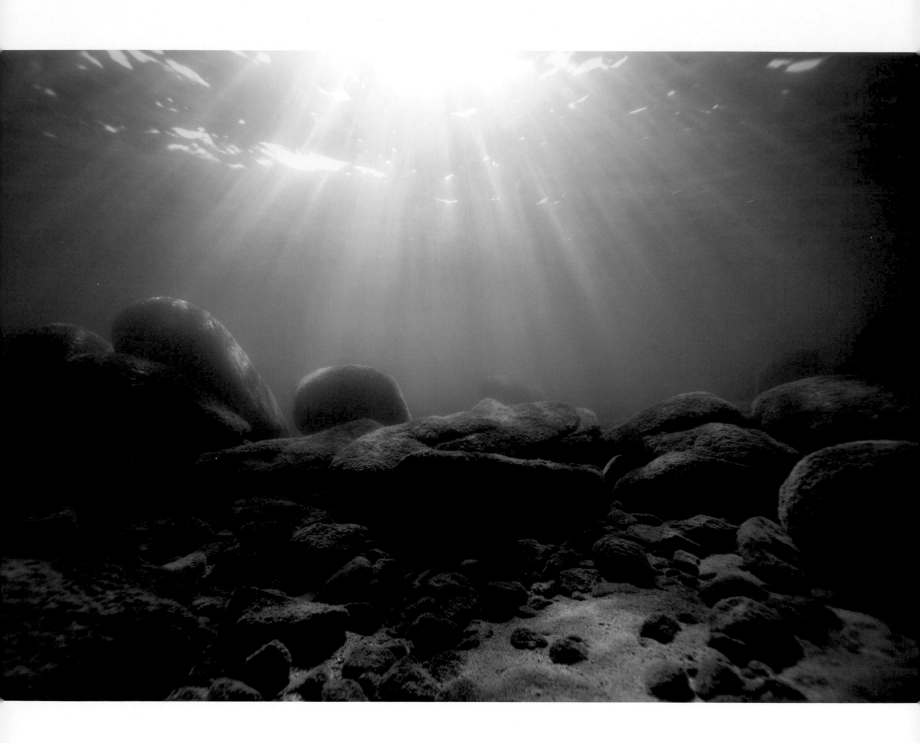

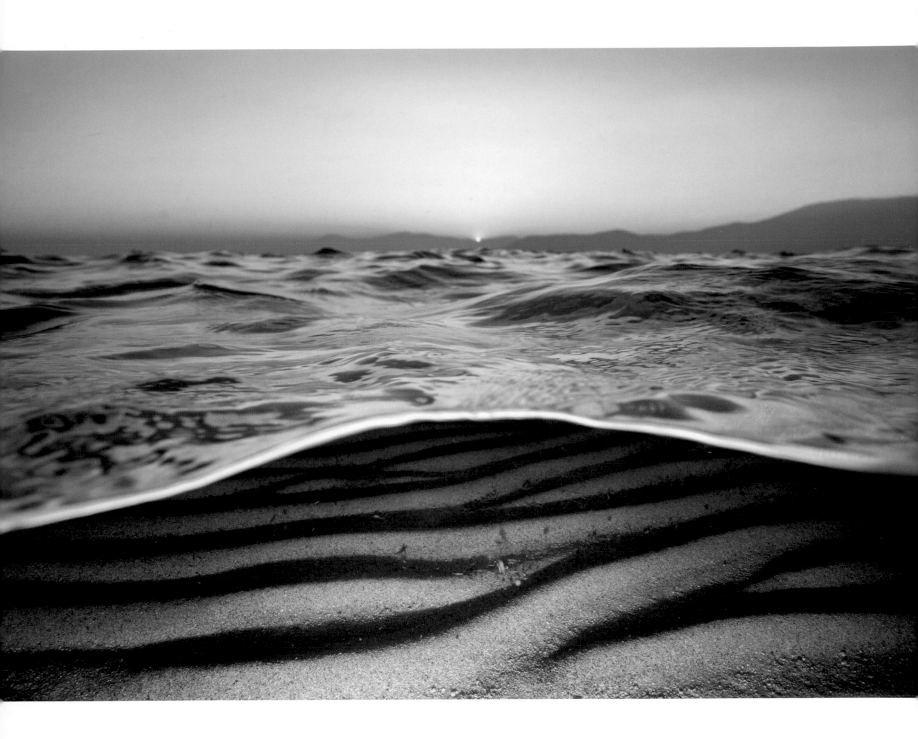

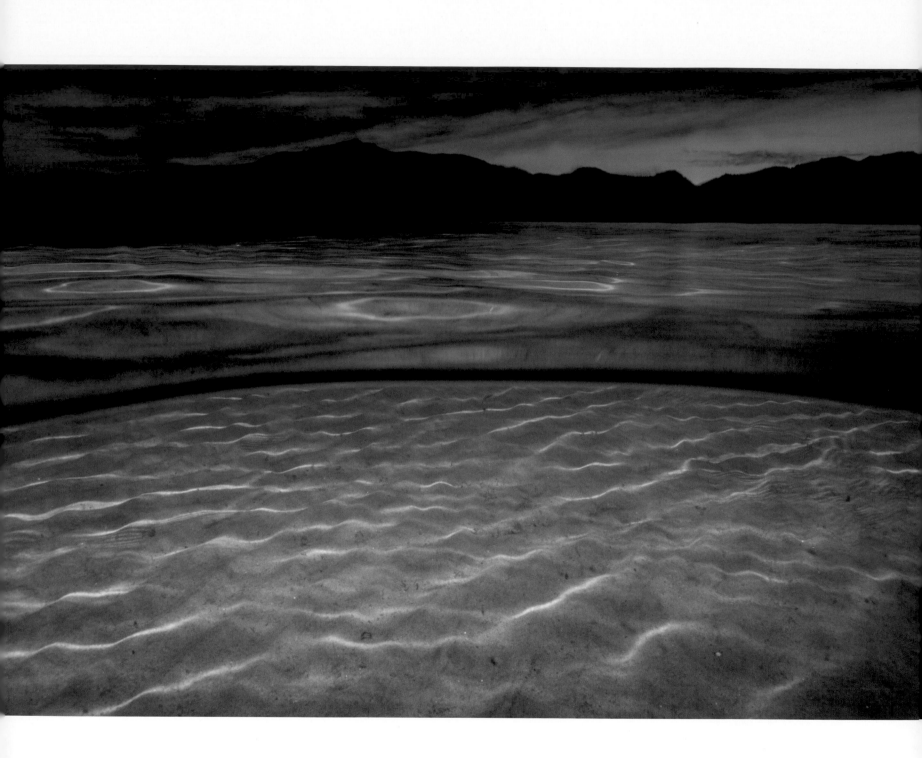

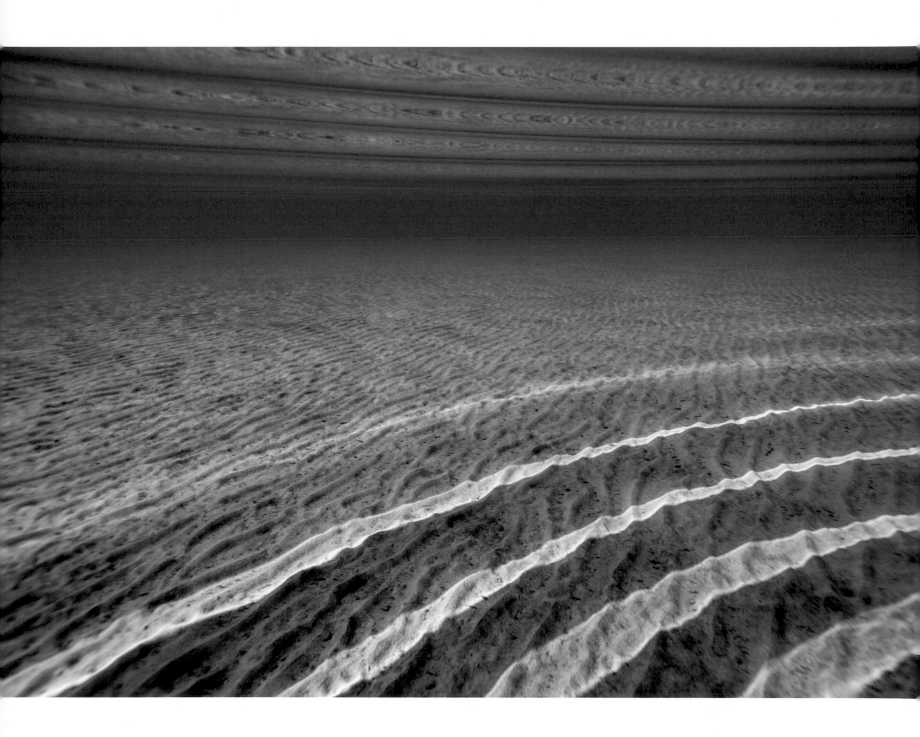

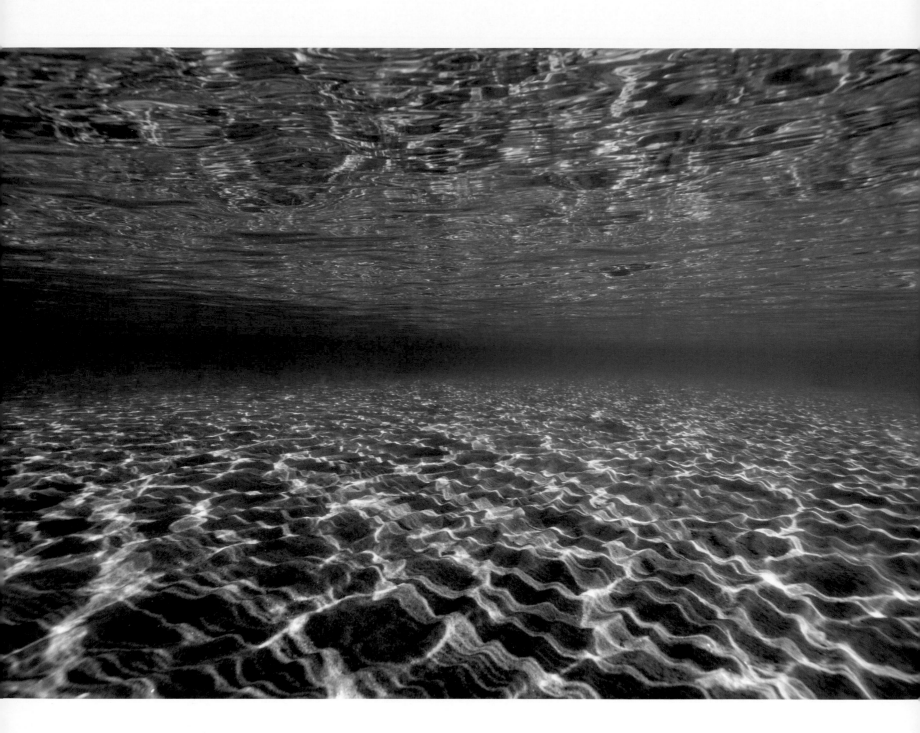

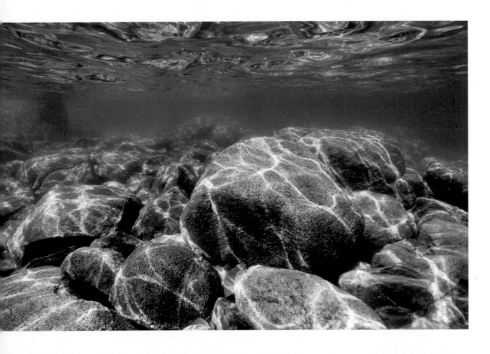
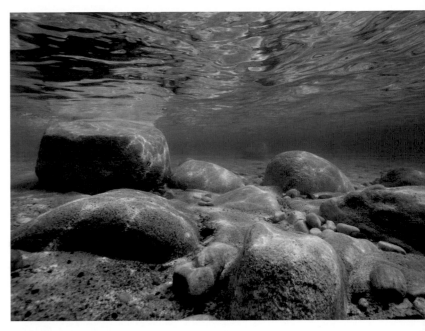
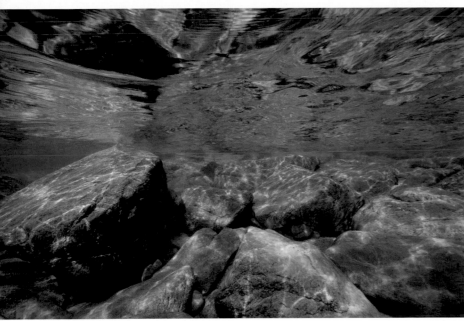
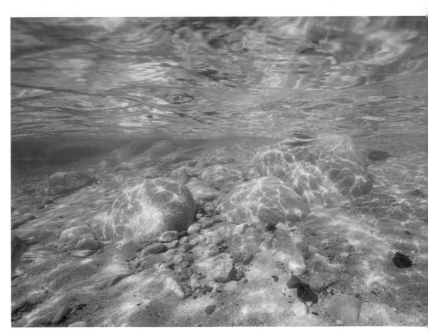

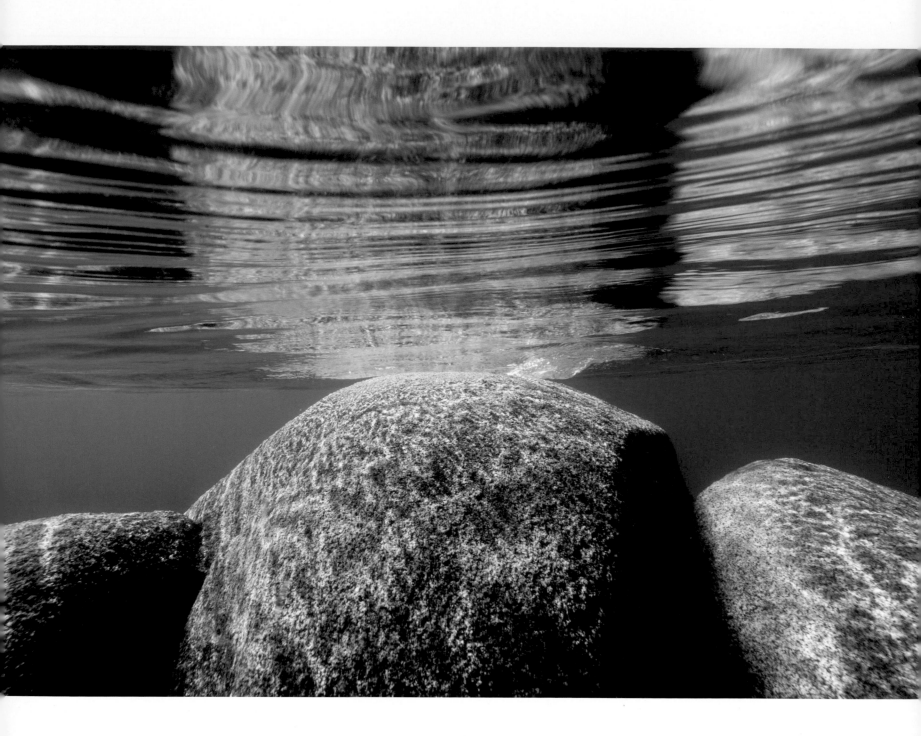

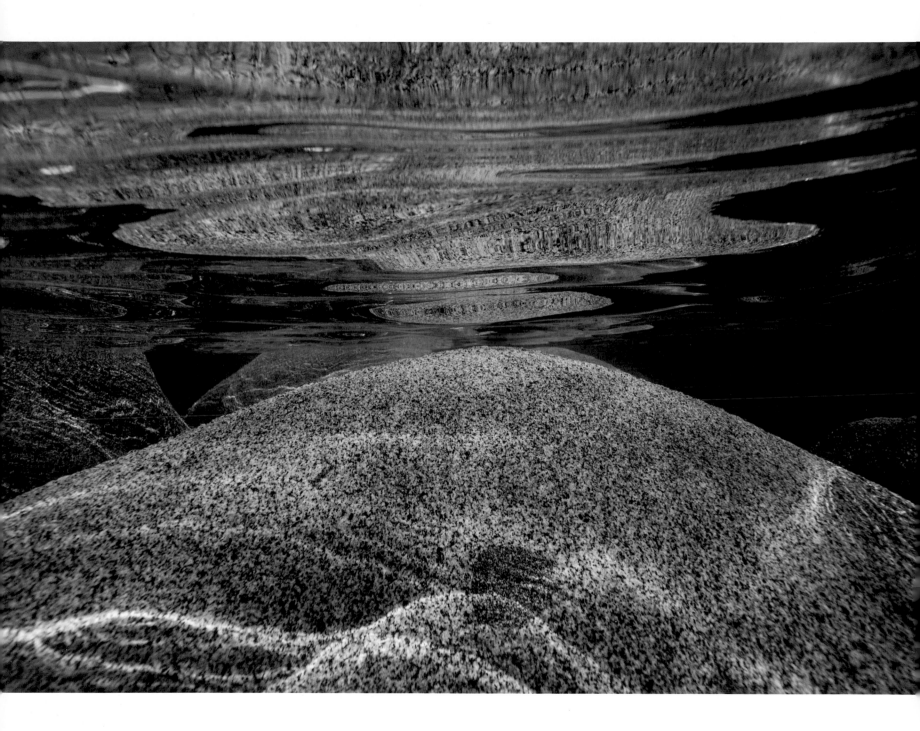

CLARITY

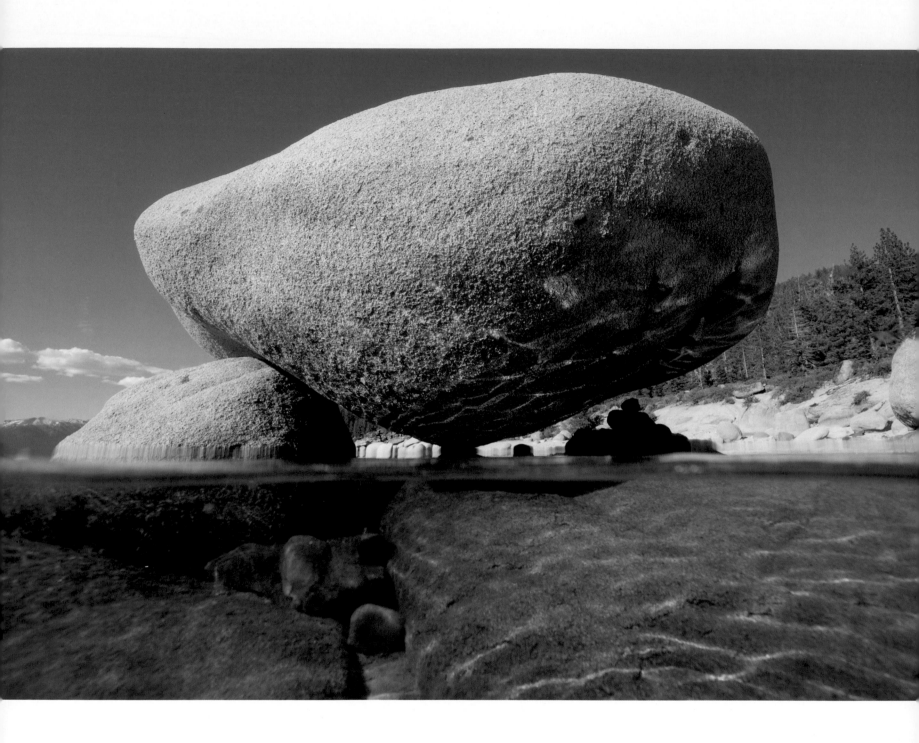

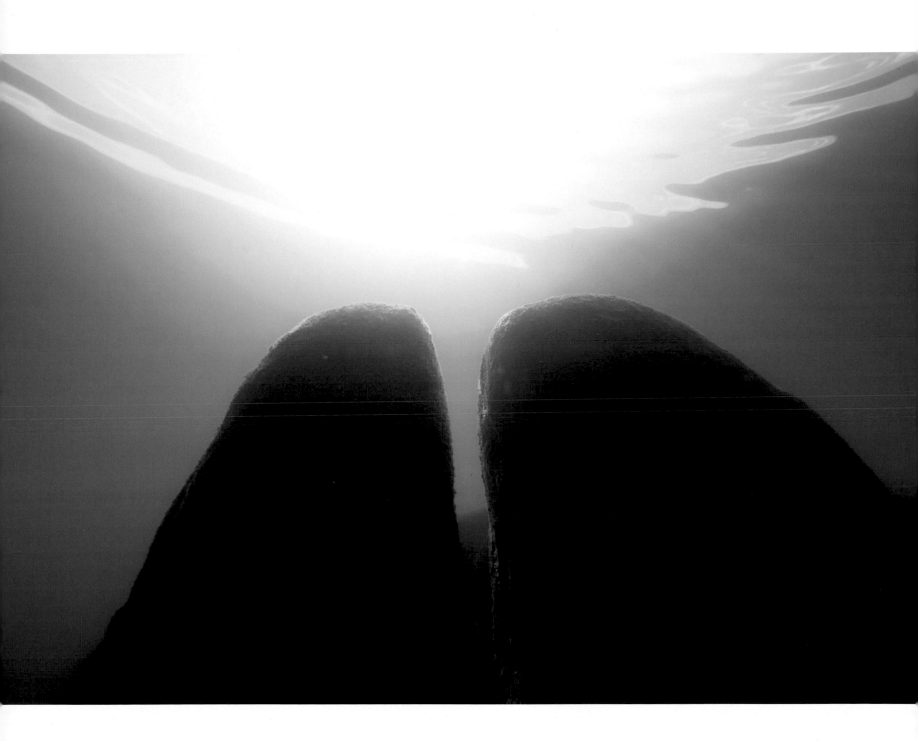

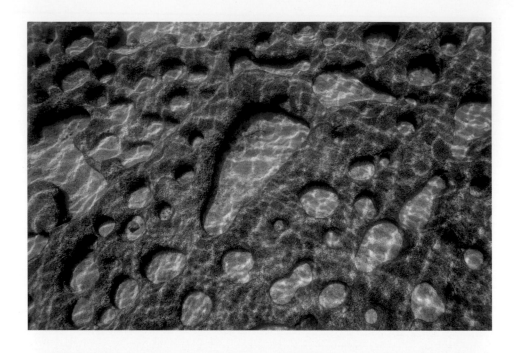

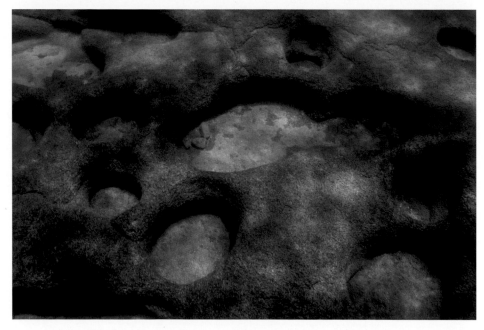

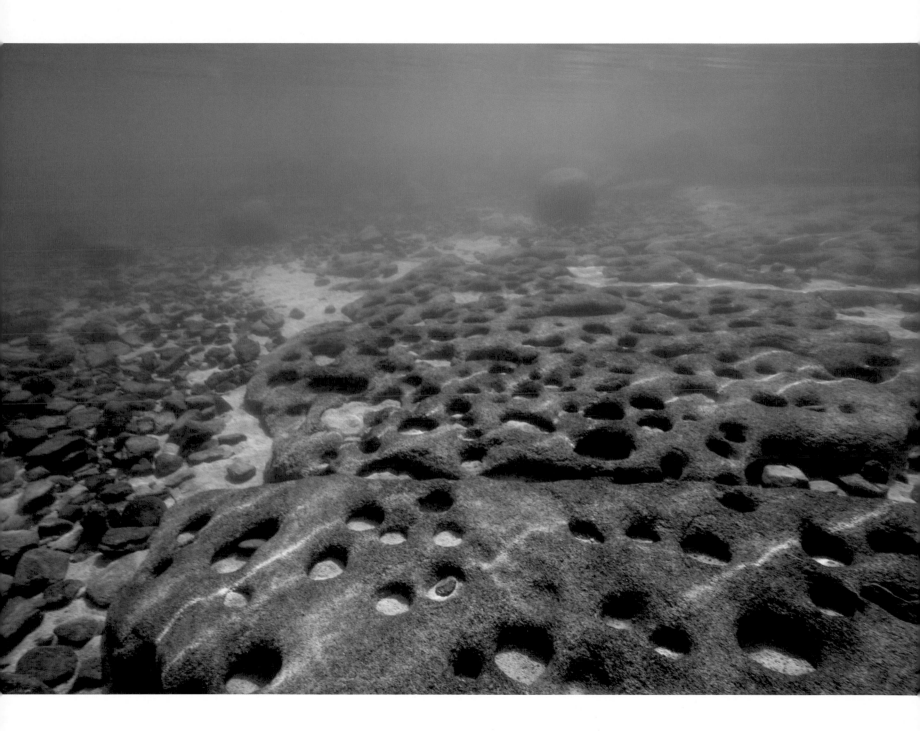

CLARITY

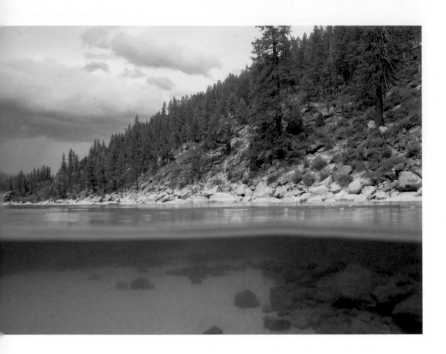
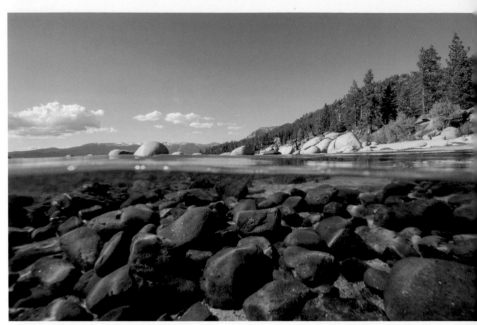
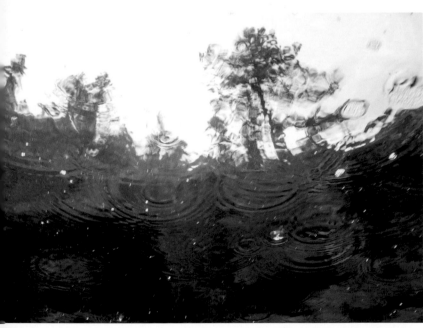
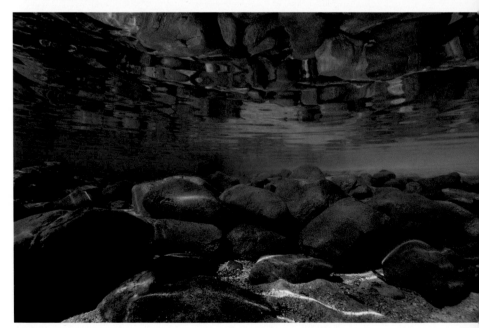

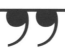

For years, the sand, boulders, and beams have been my temple. It's where I've gone to enjoy just being alive in a beautiful place.

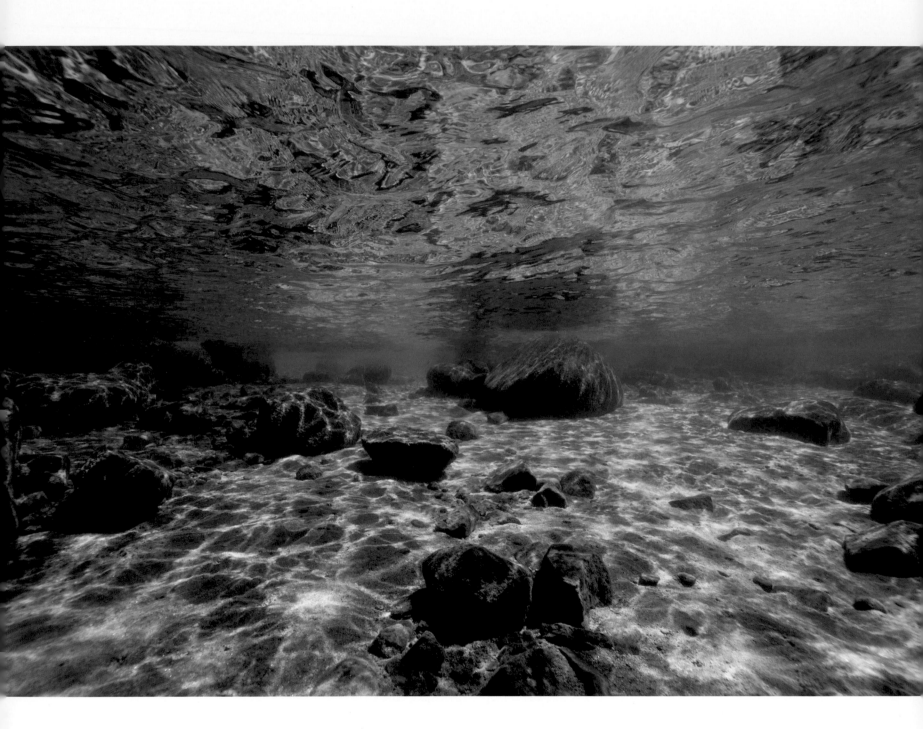

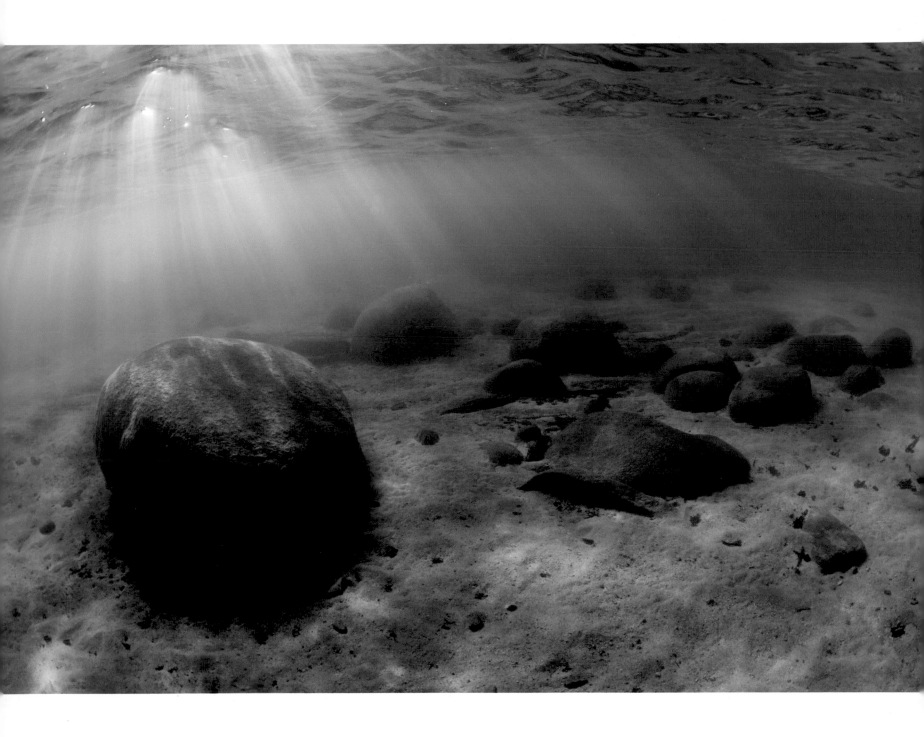

CLARITY

CLARITY

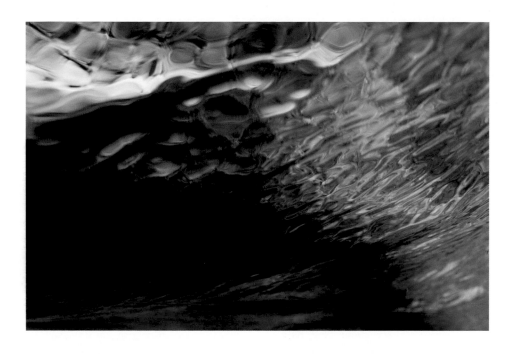

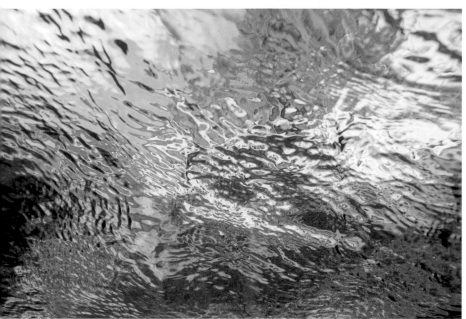

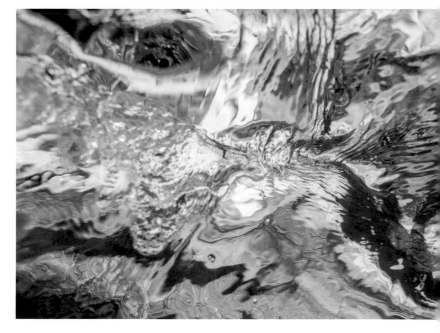

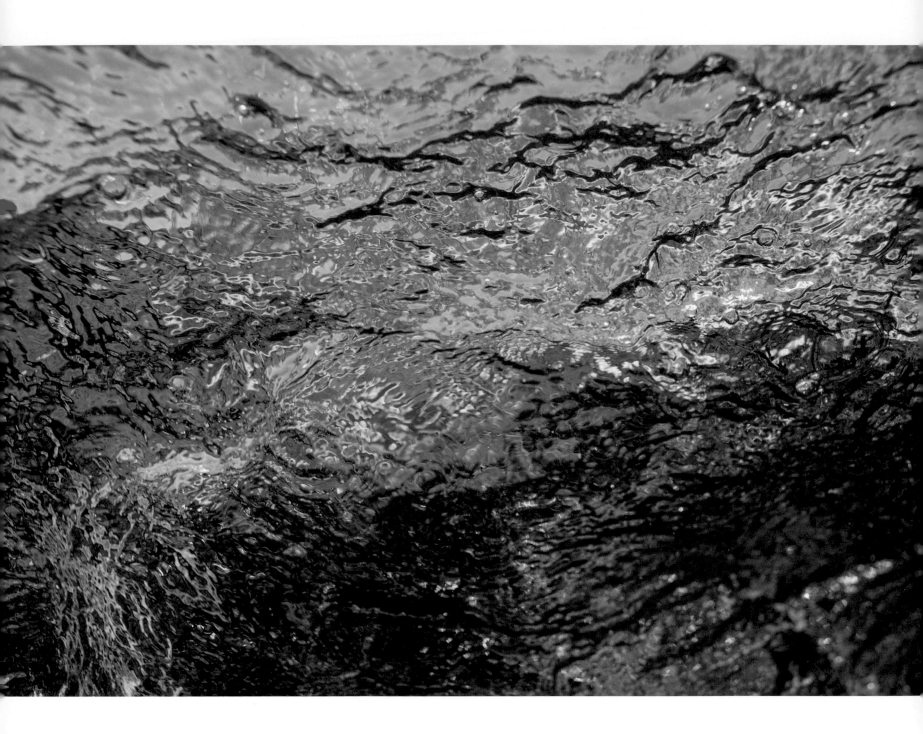

CLARITY

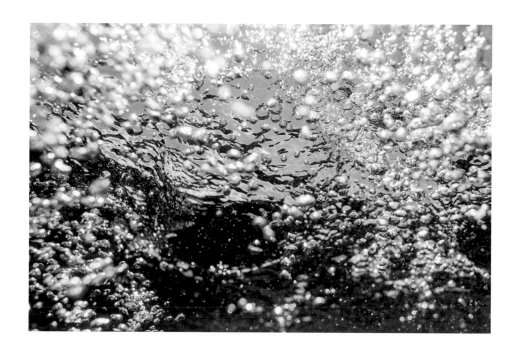

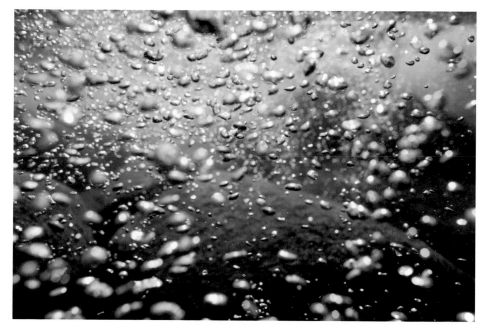

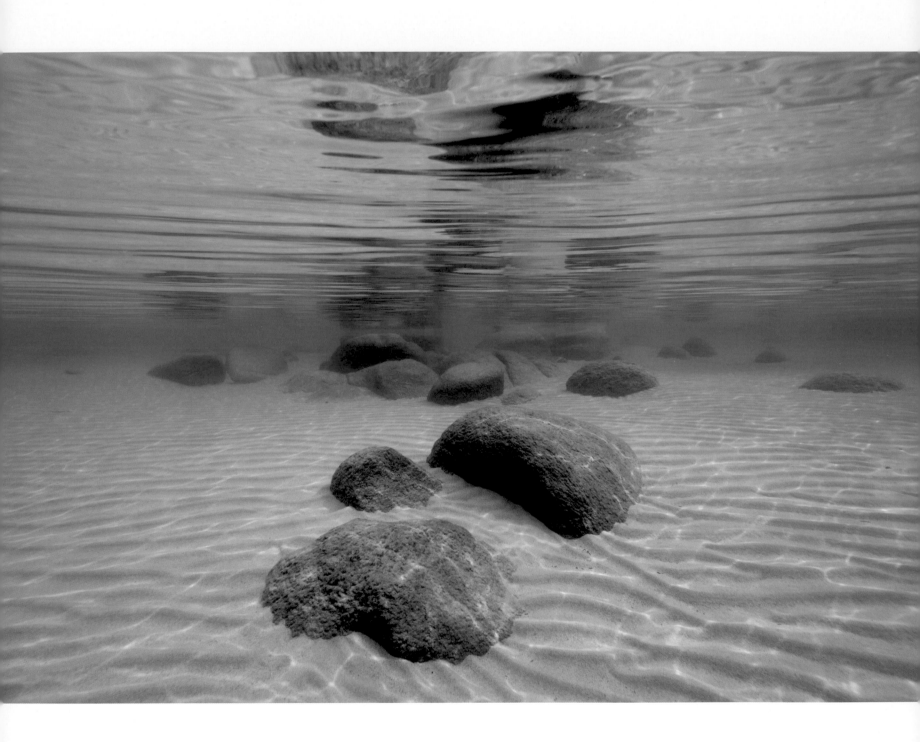

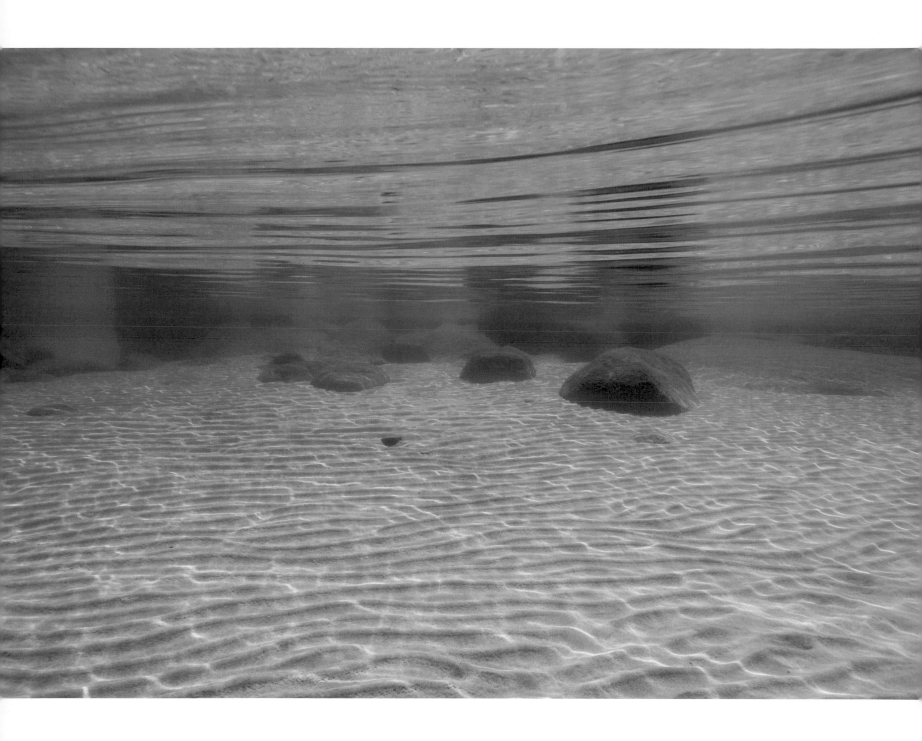

CLARITY

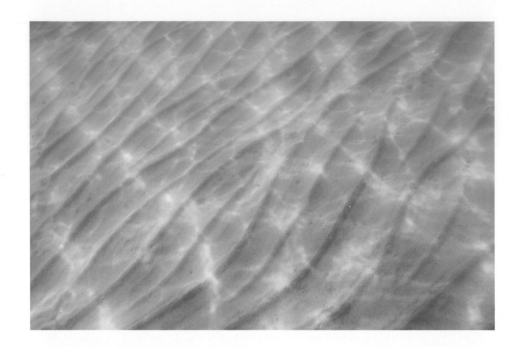

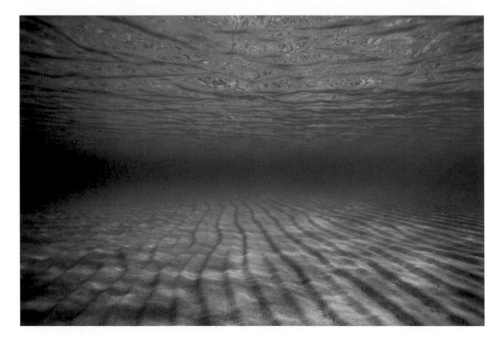

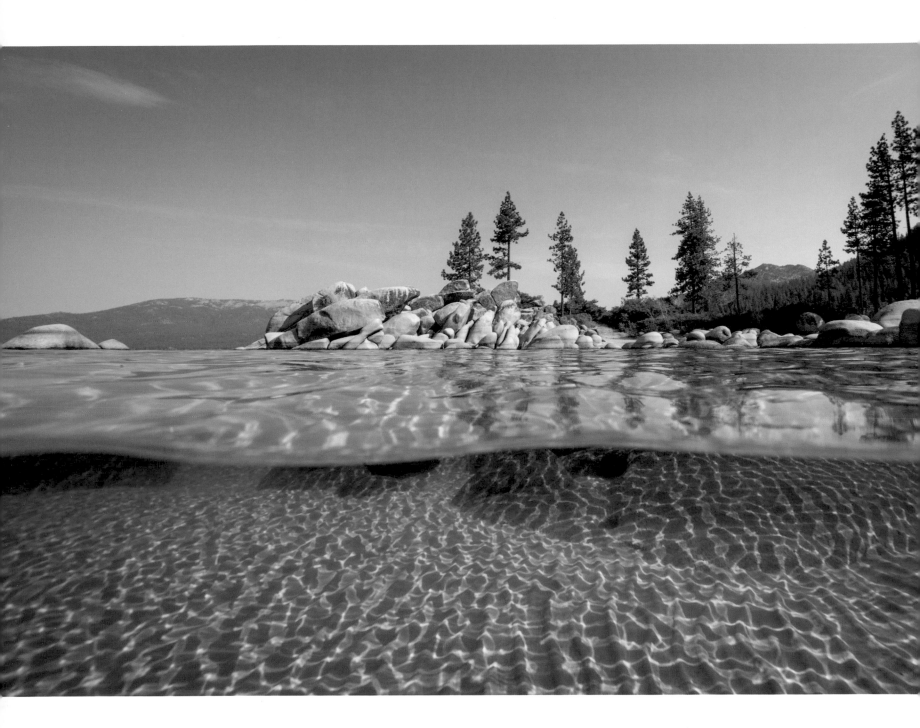

CLARITY

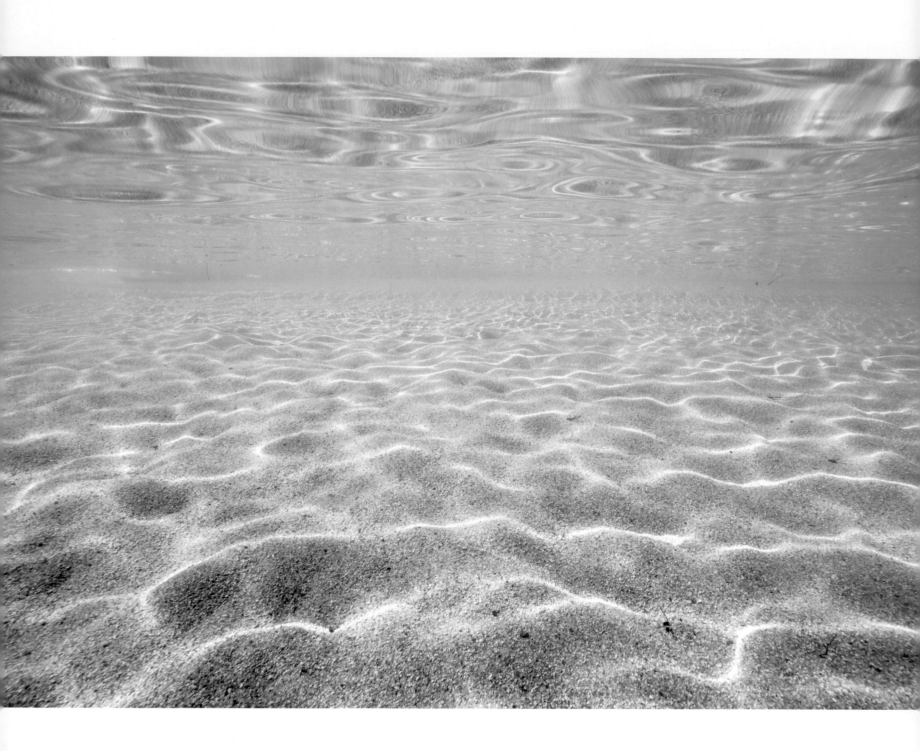

CLARITY

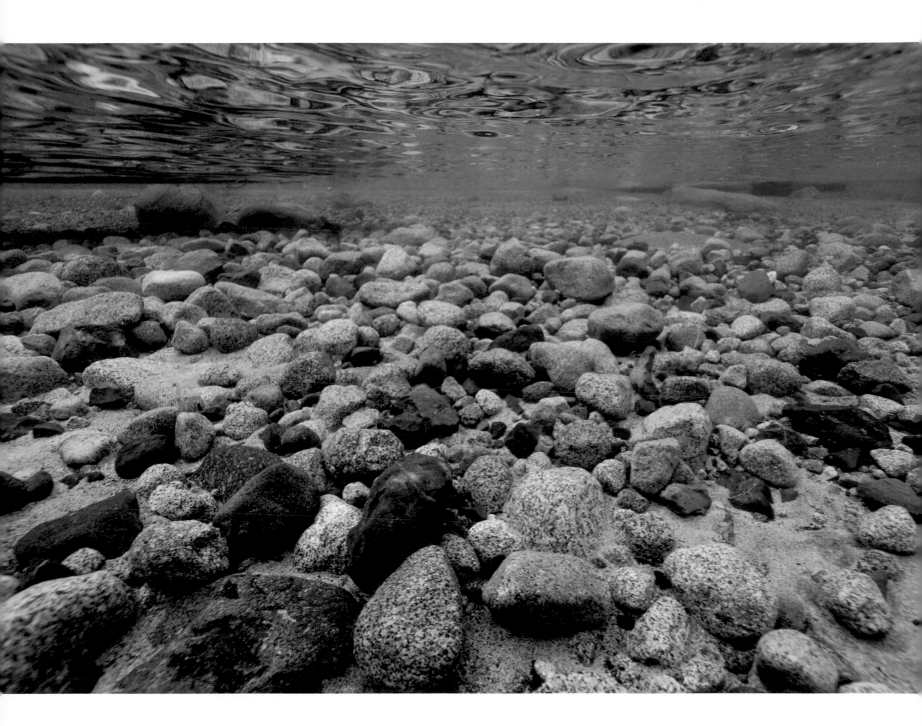

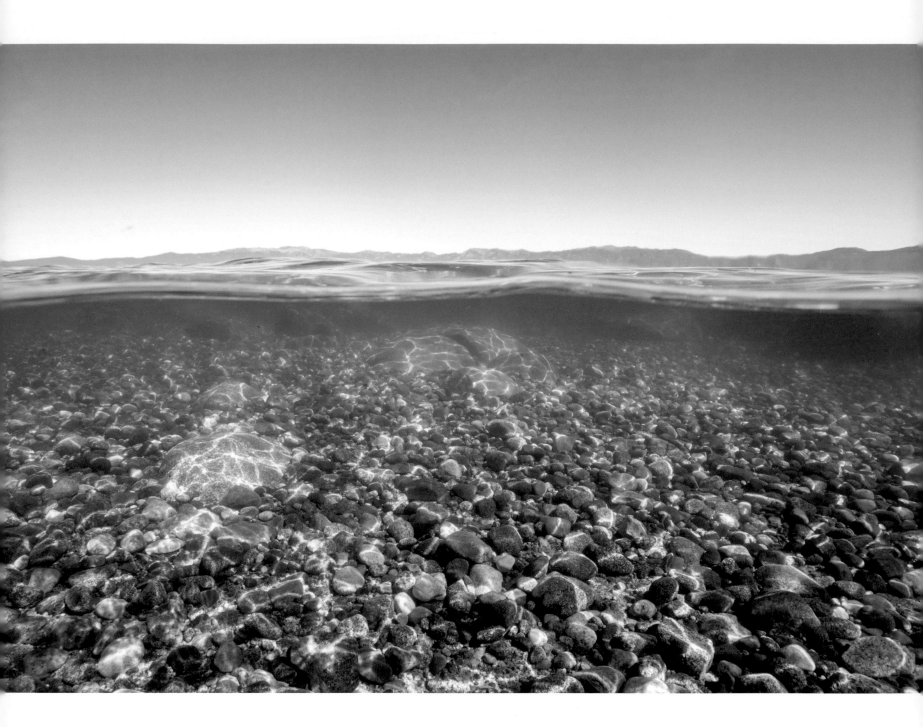

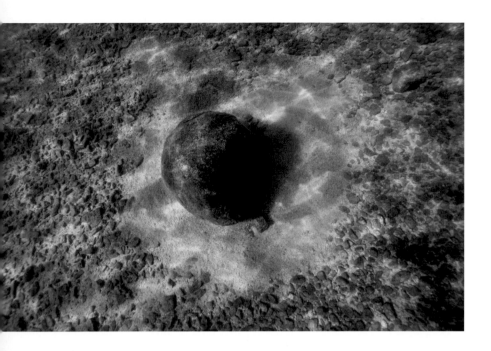

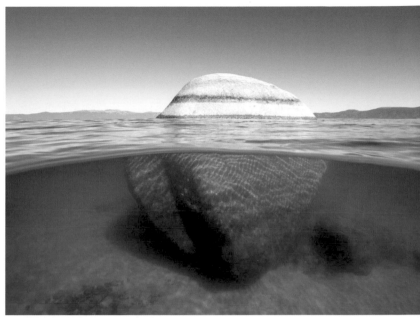

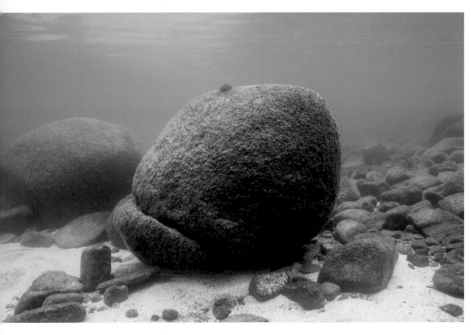

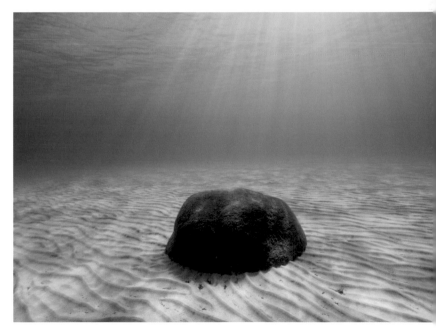

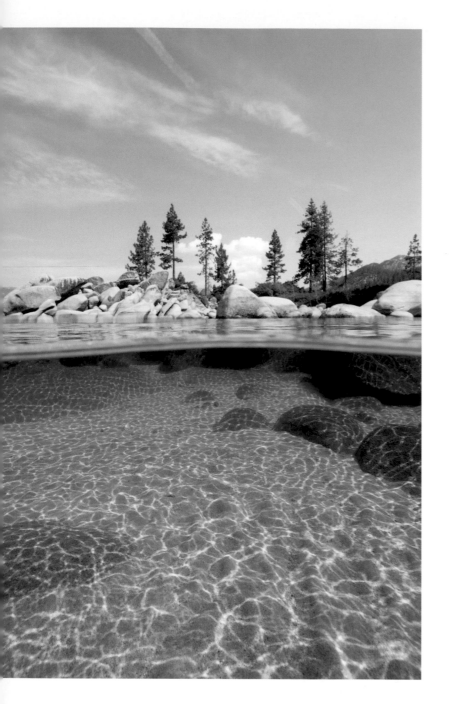

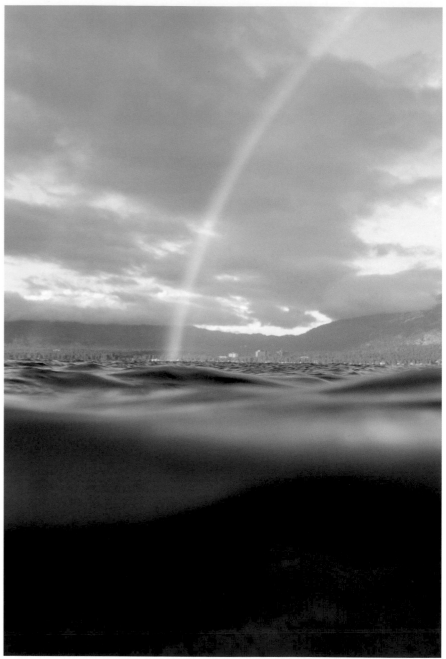

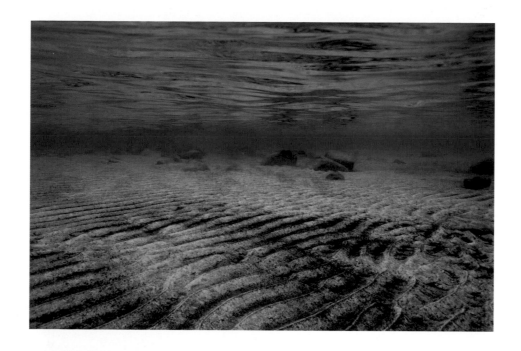

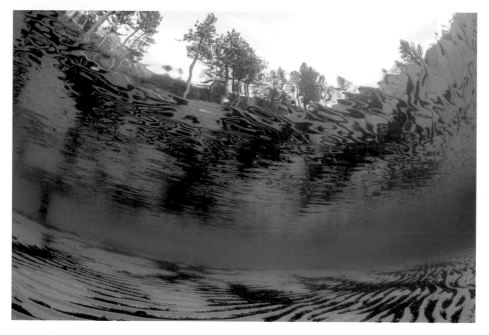

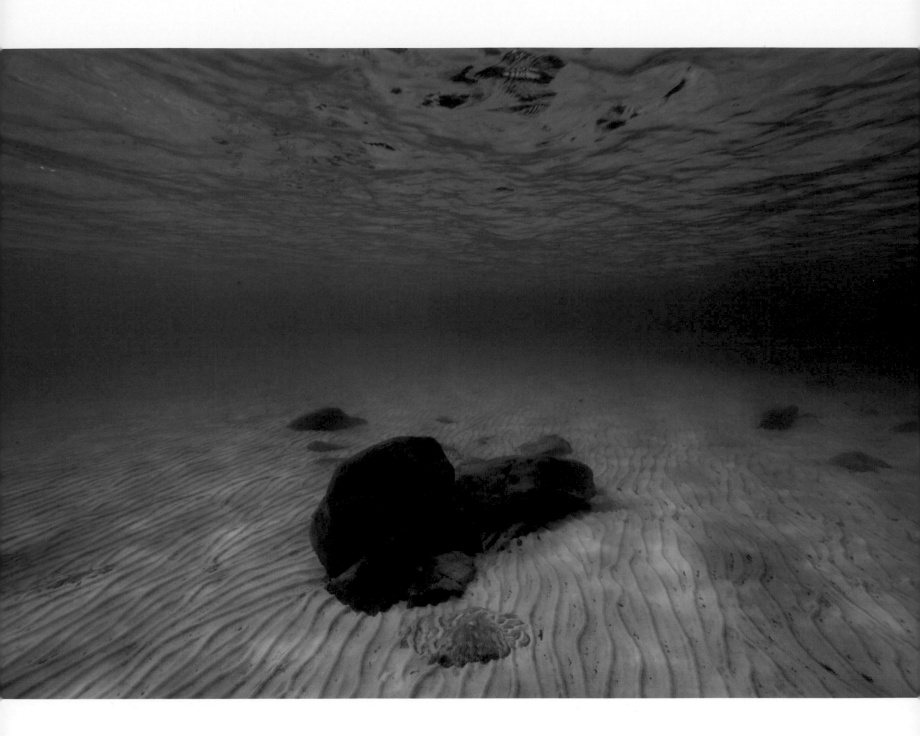

CLARITY

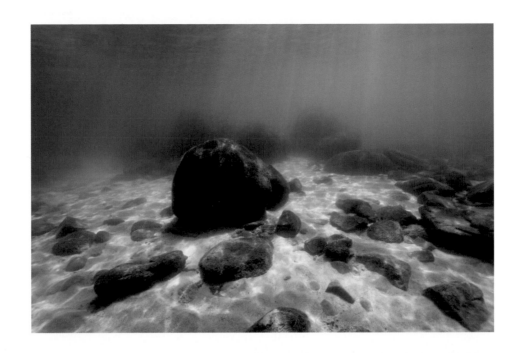

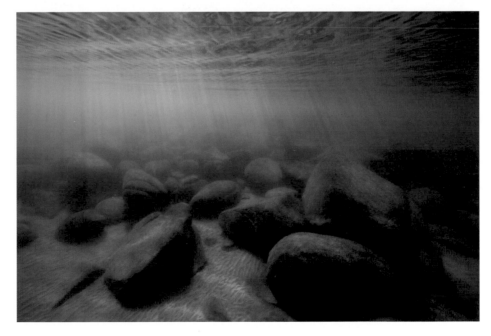

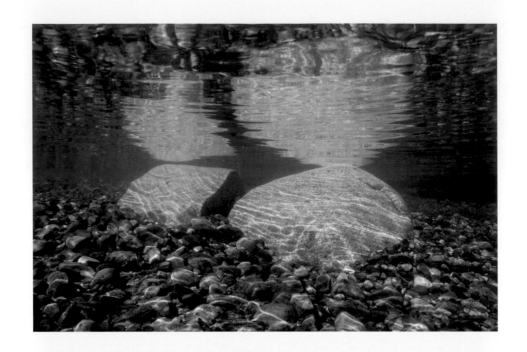

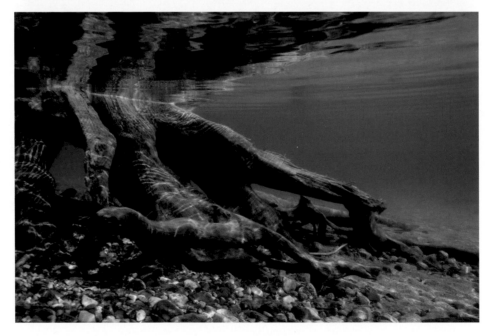

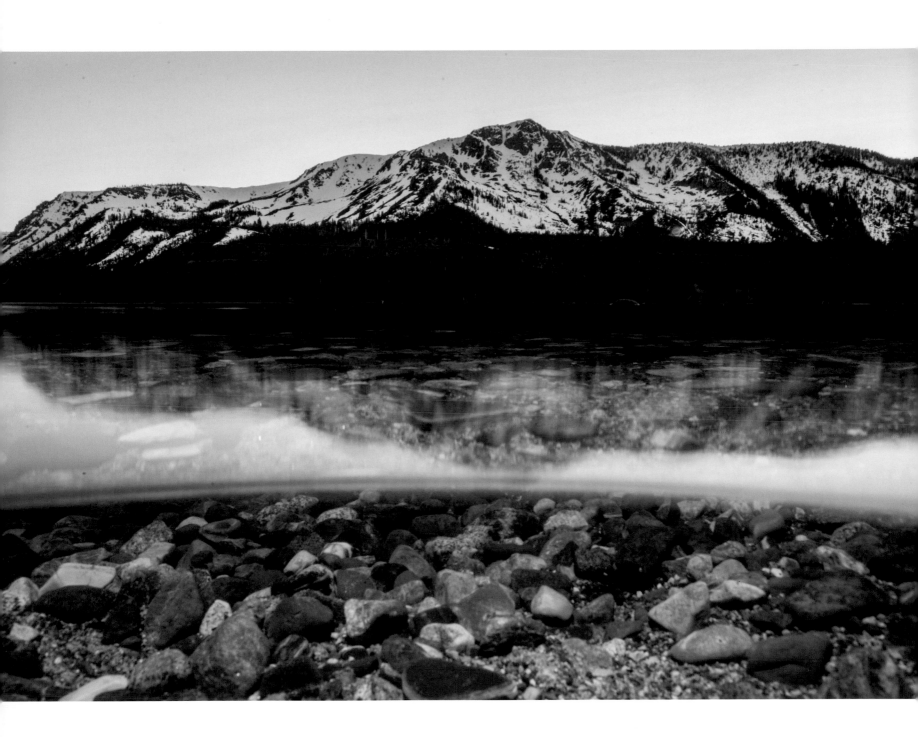

CLARITY

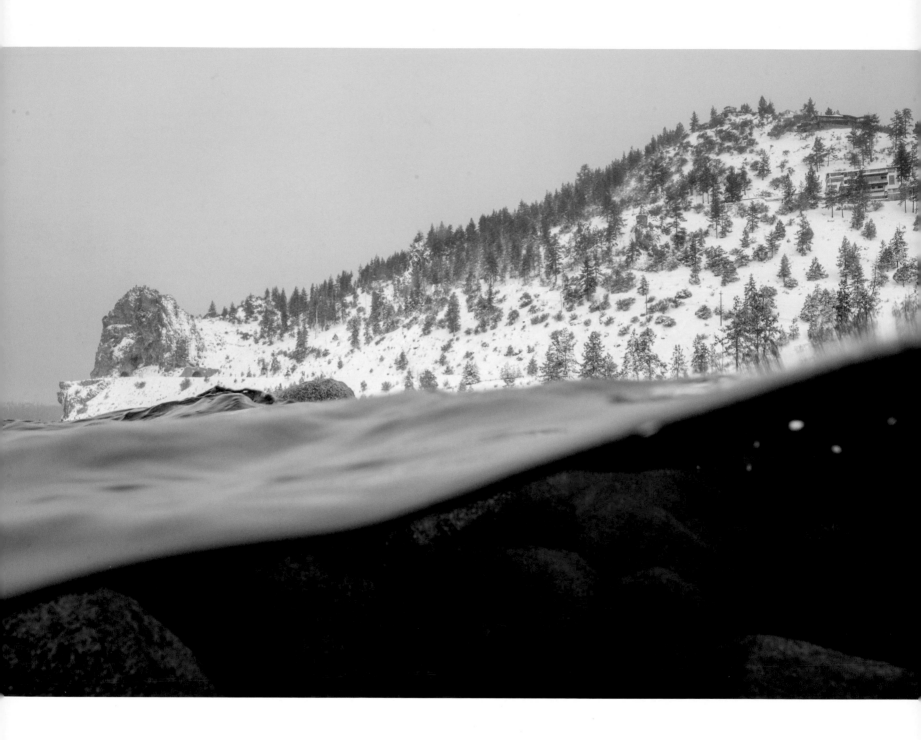

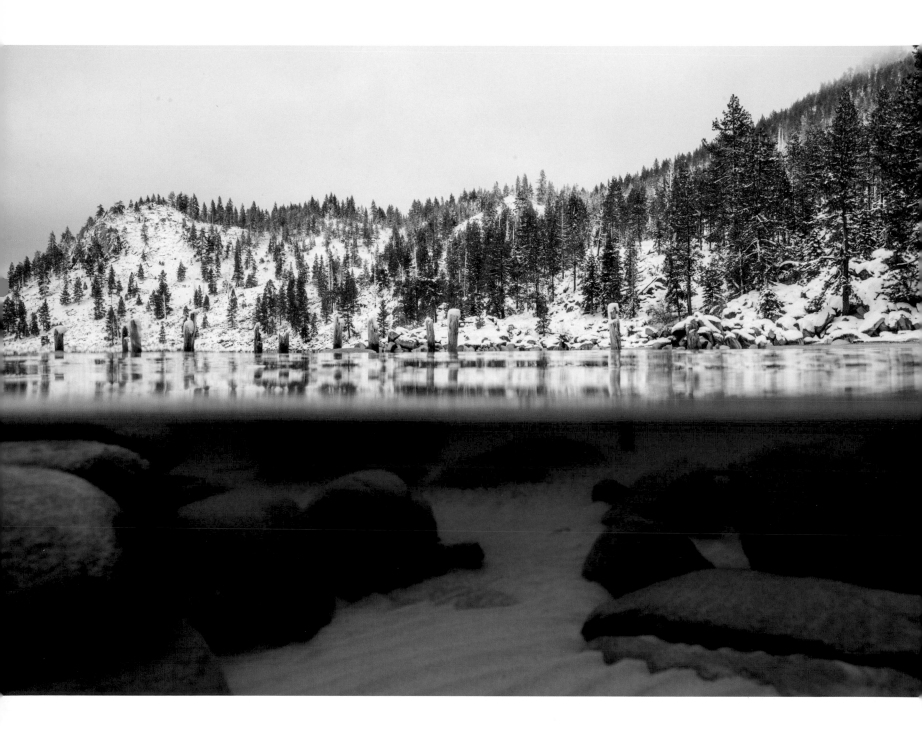

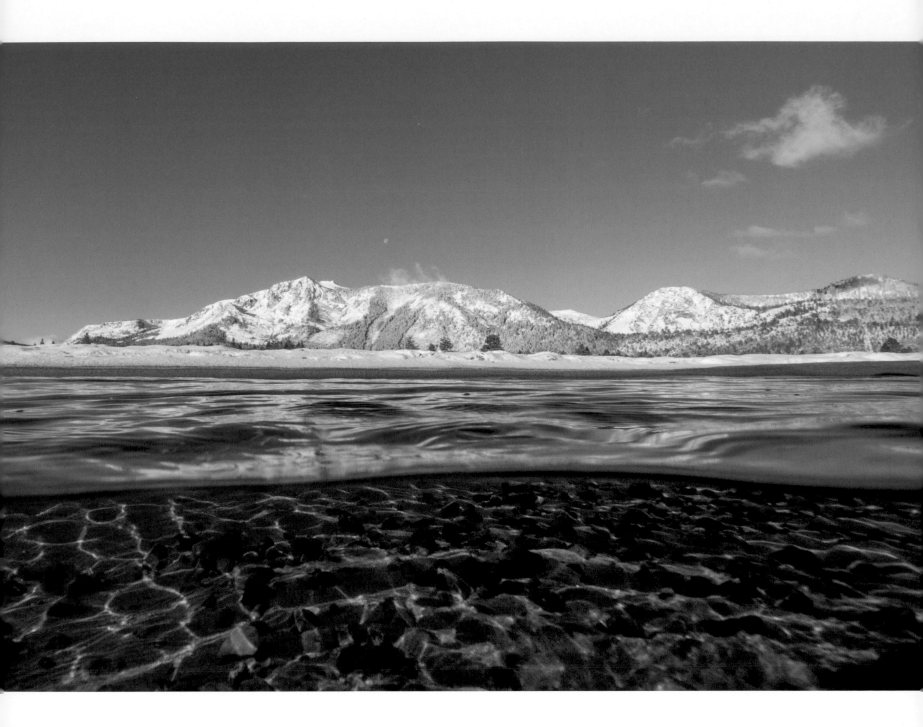

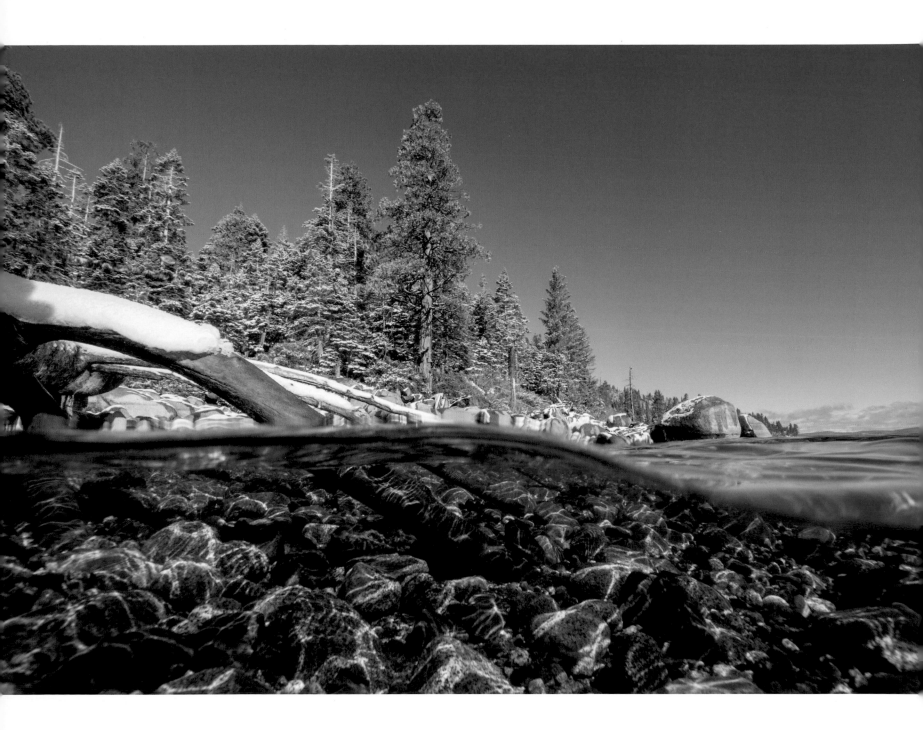

CLARITY

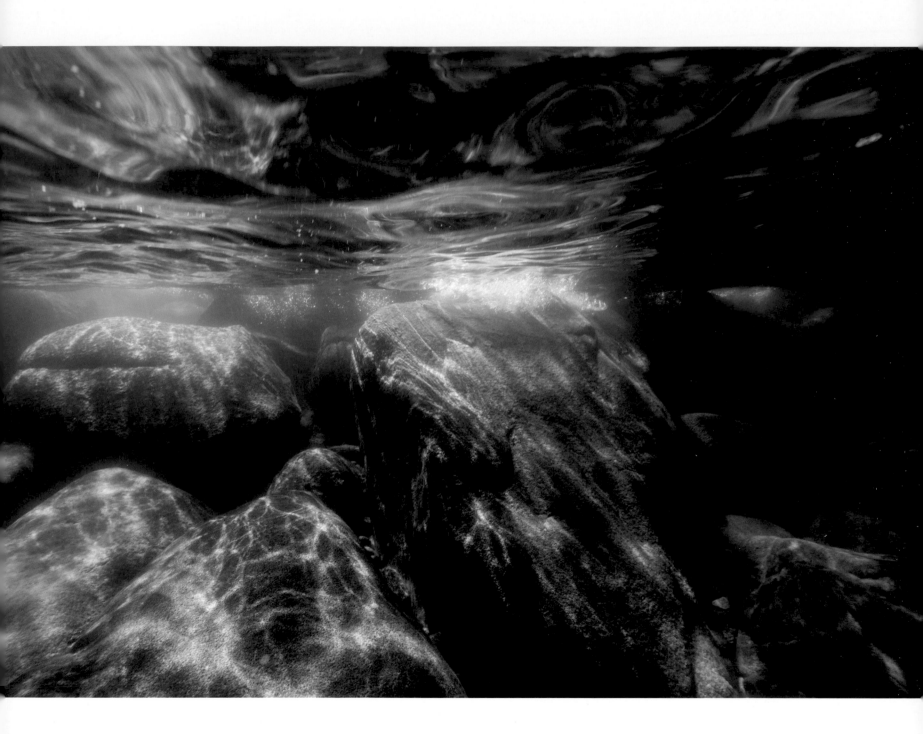

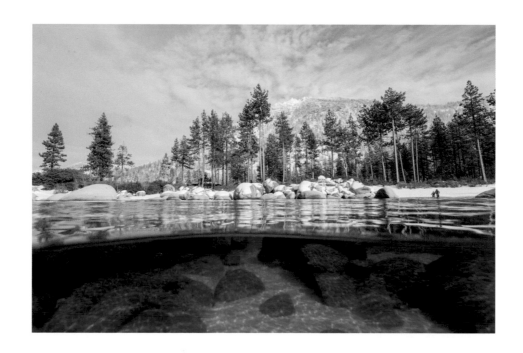

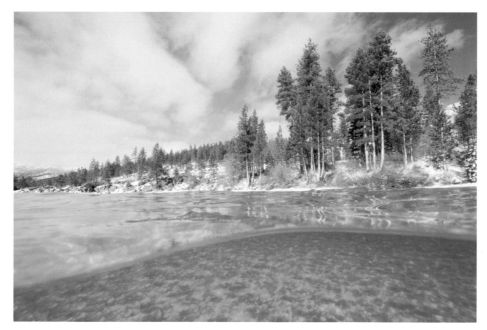

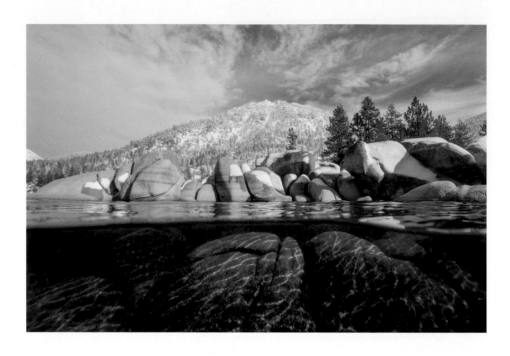

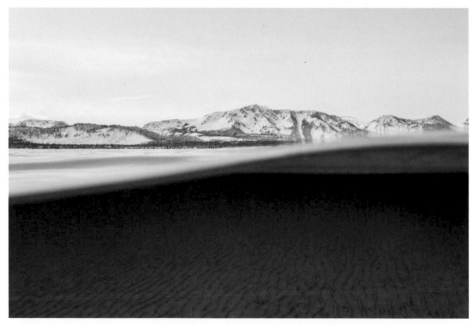

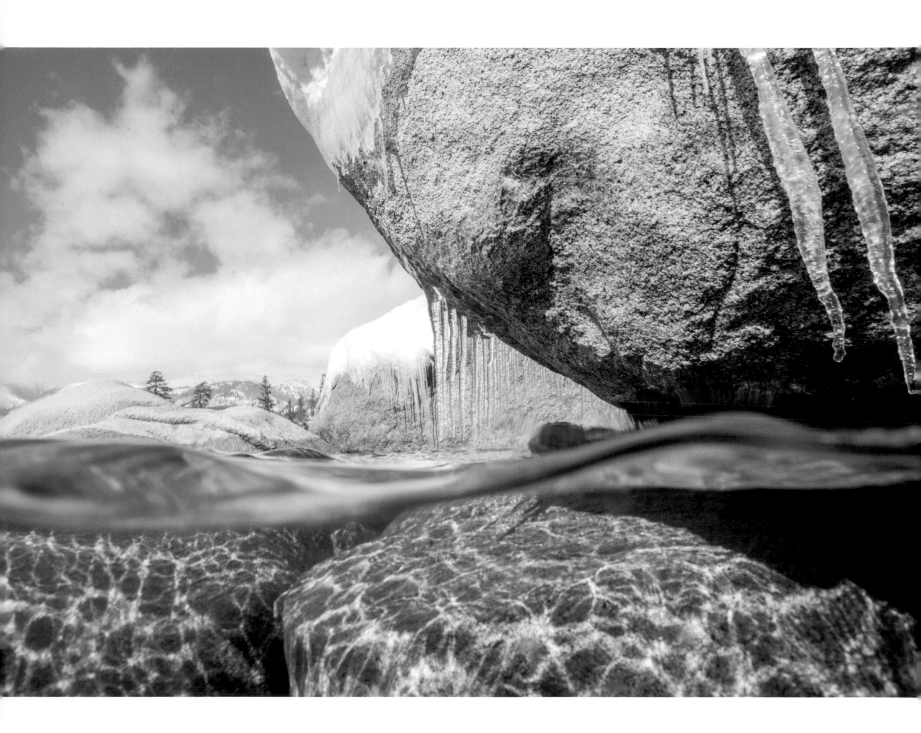

MOVEMENT

Watching Tahoe's waves crash against the rocks is oddly mesmerizing. The water is so clear and filled with so much color, it's like splashing liquid glass. The uneven contours of the boulder-strewn shoreline cause wobbles and spouts as the swells wash up the banks and roll back into the lake. These bizarre and surreal shapes form faster than the eye can see and the mind can conceive. The only way to really understand the movement is through fast camera settings and the motor drive of a camera's shutter.

It wasn't uncommon during these sessions to shoot thousands of images, hunting for one perfect shot. I often beached myself on a shallow boulder and let the waves wash over me and past my lens. I tried to anticipate the chaotic movement and press the shutter at just the right time. For me, much of the excitement was flipping through the photos after a shoot to see the results. There were countless other shots that would've been spectacular, if only the shutter had dropped a fraction of a second earlier or later. It's that roll of the dice that keeps me coming back to the waves.

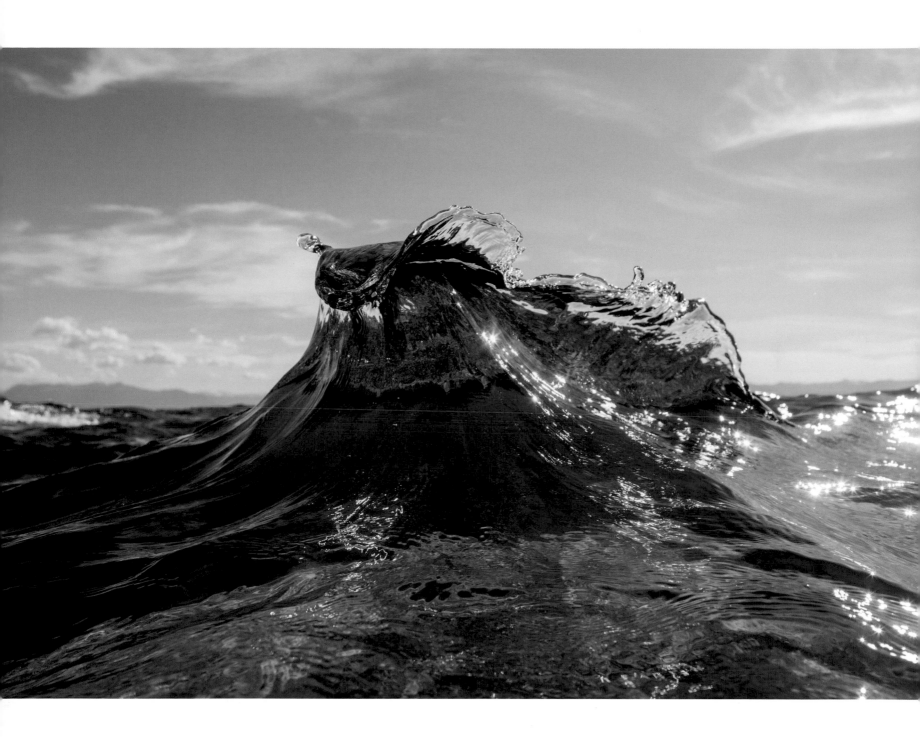

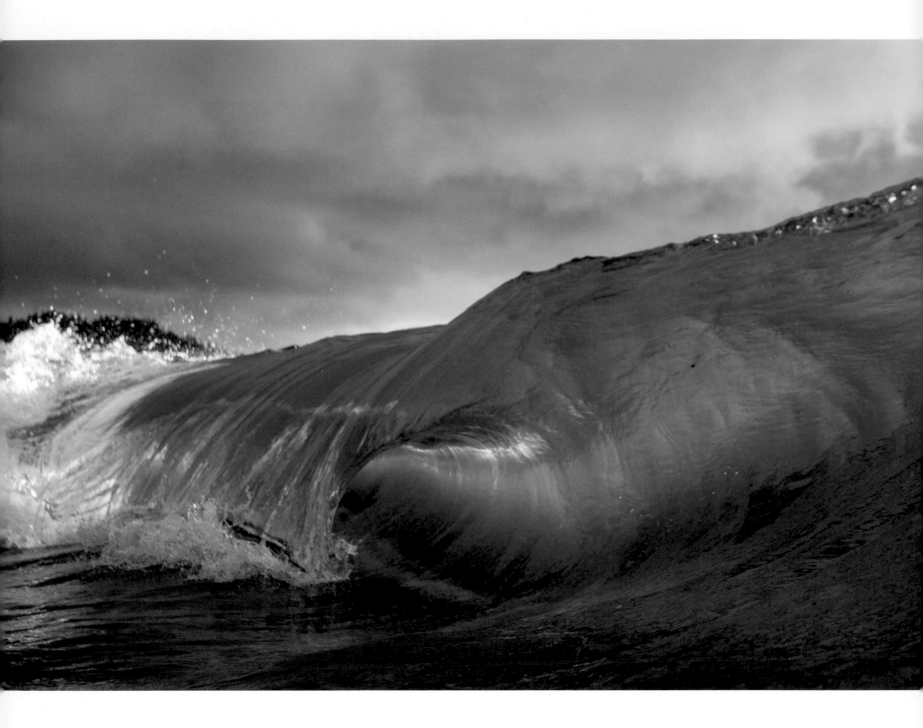

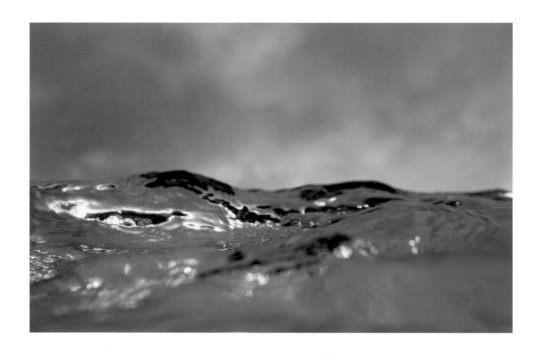

CLARITY

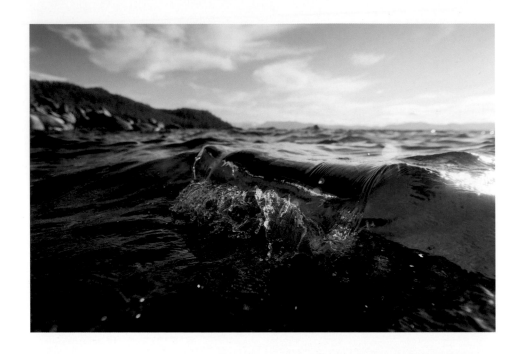

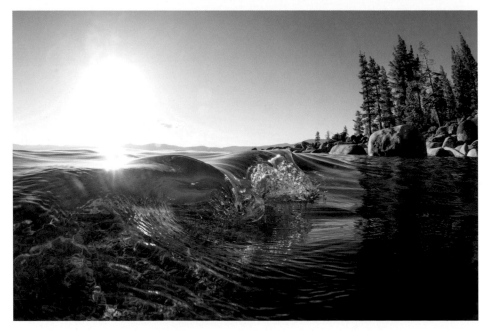

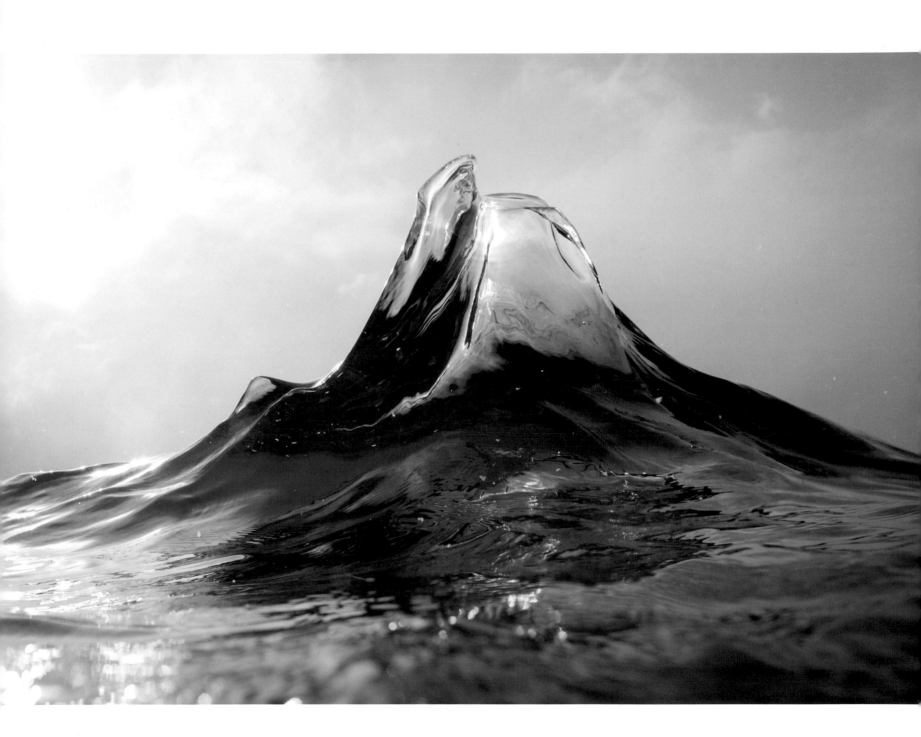

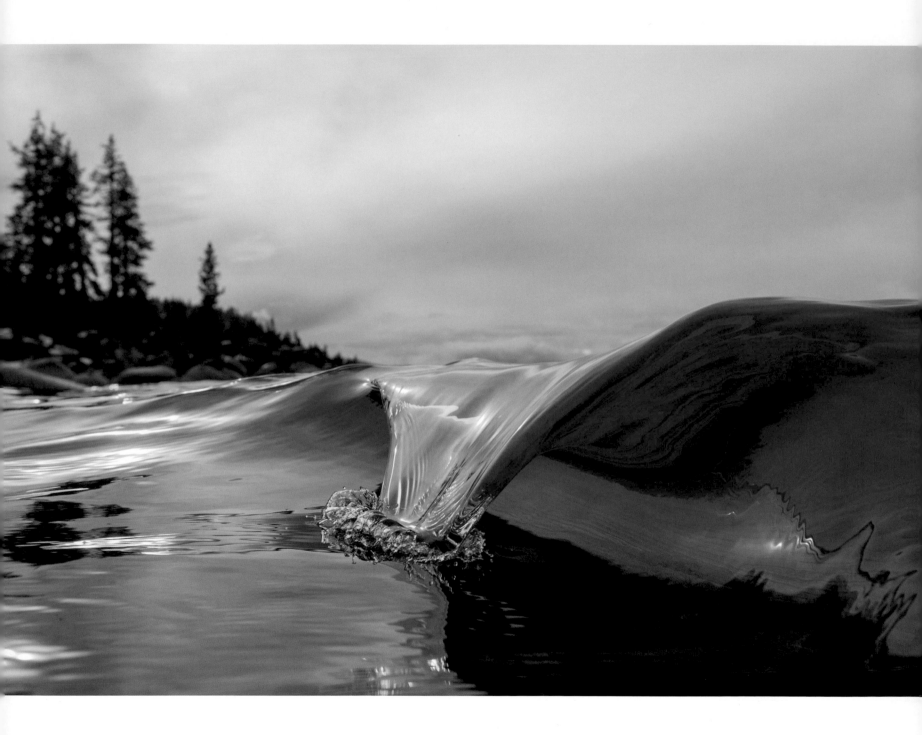

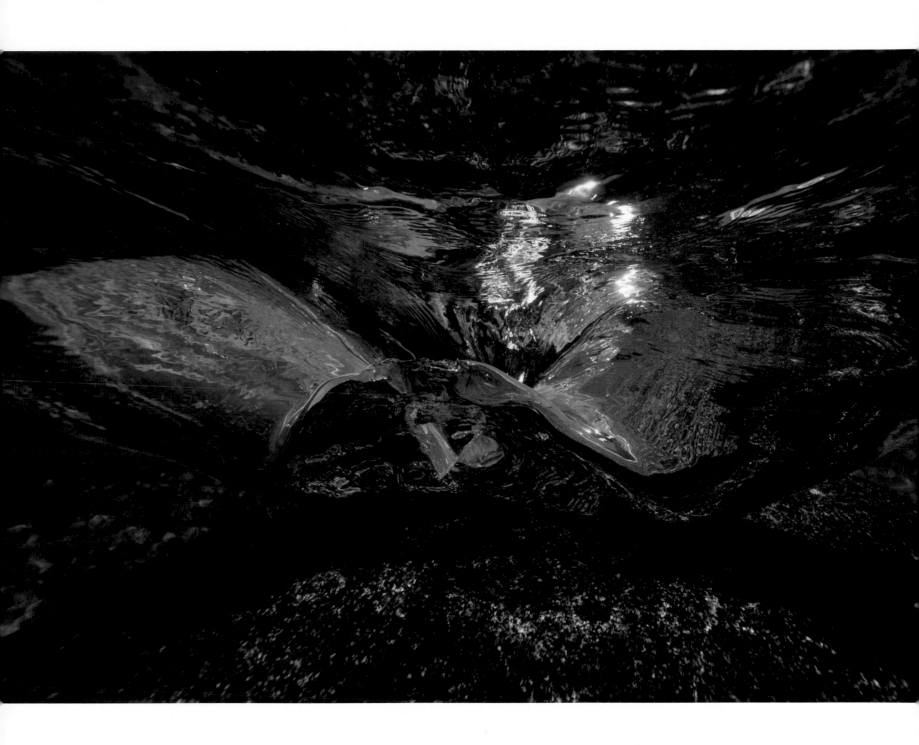

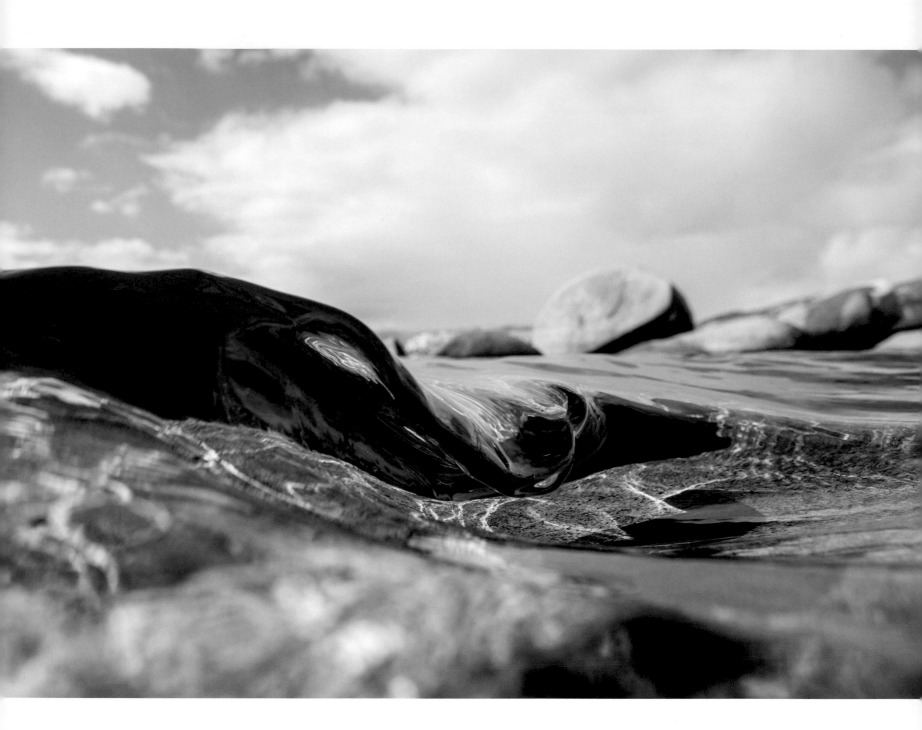

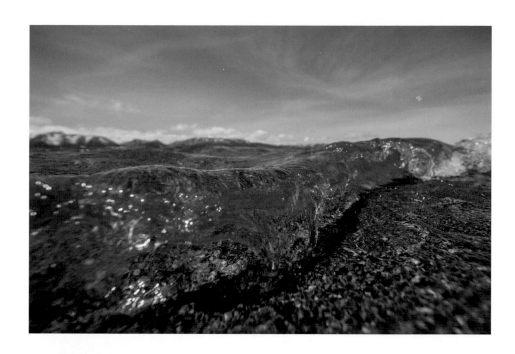

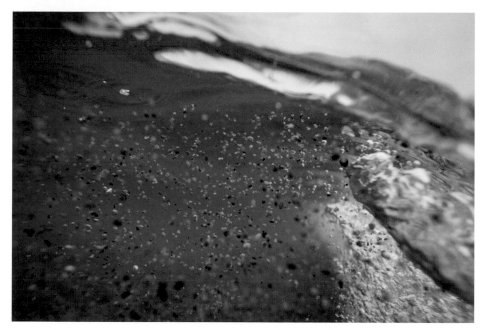

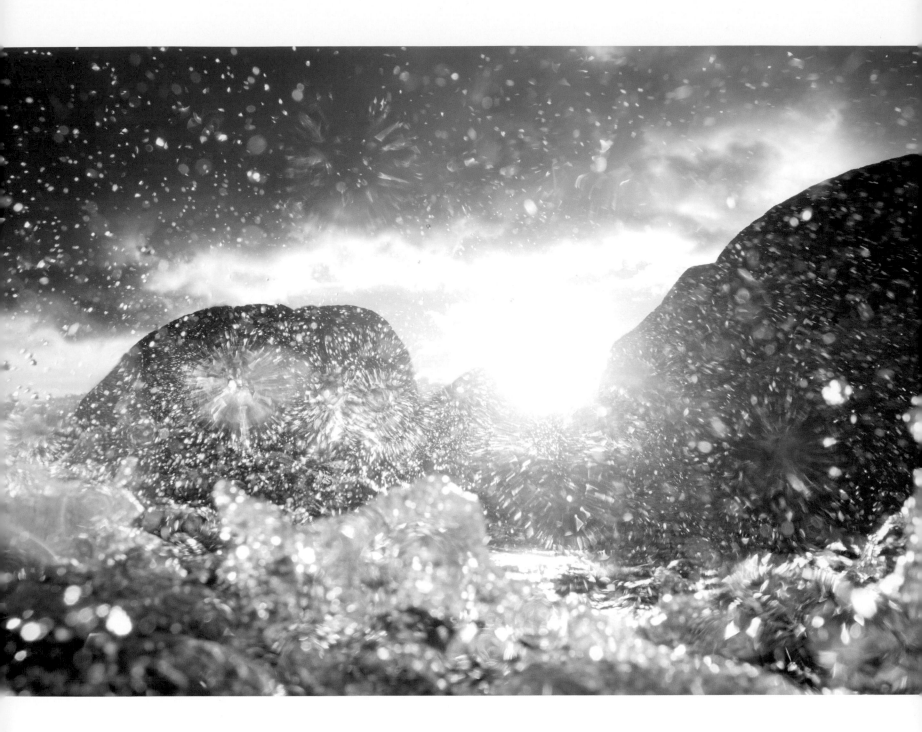

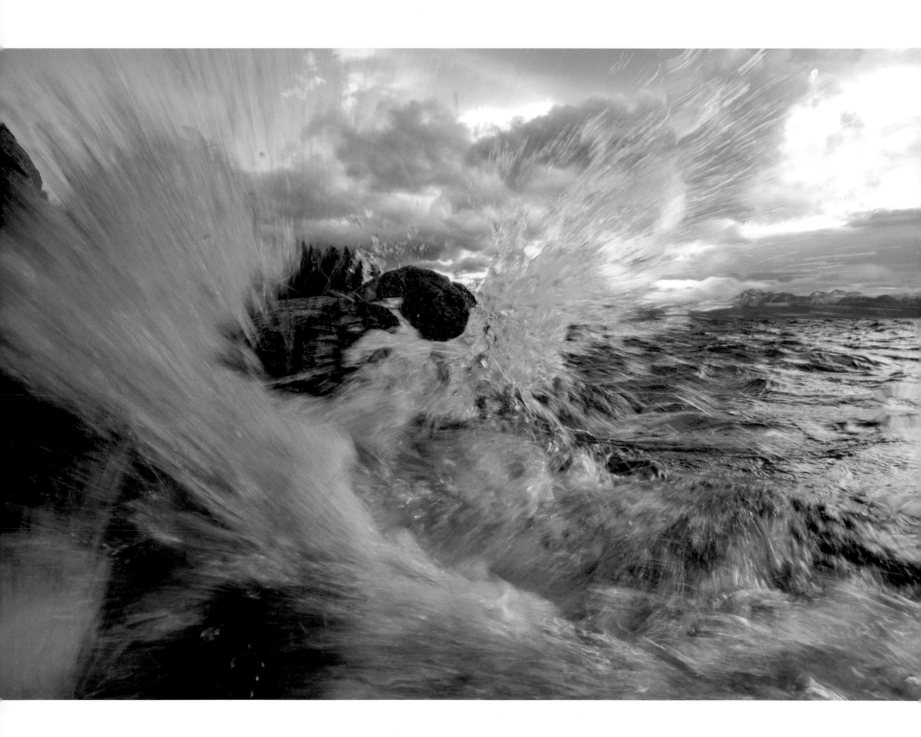

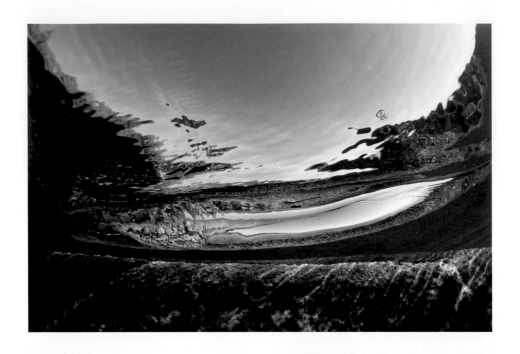

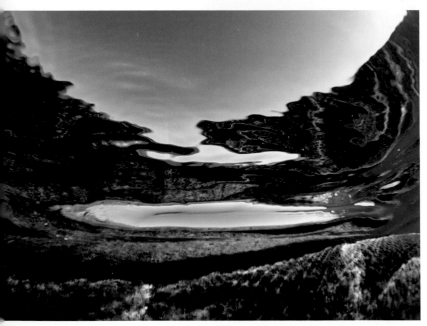

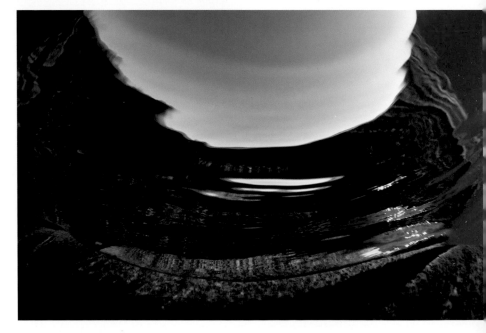

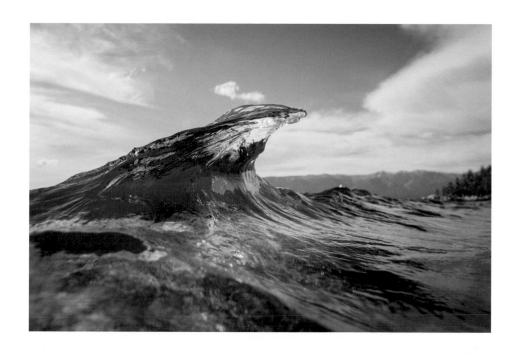

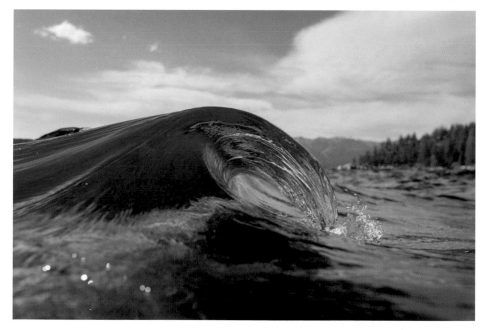

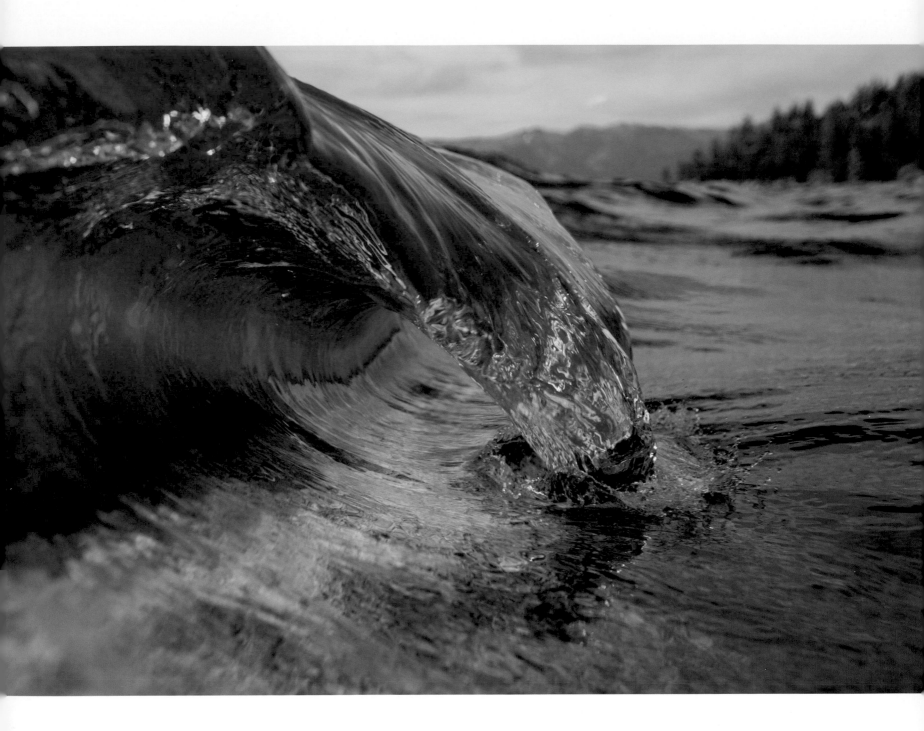

CLARITY

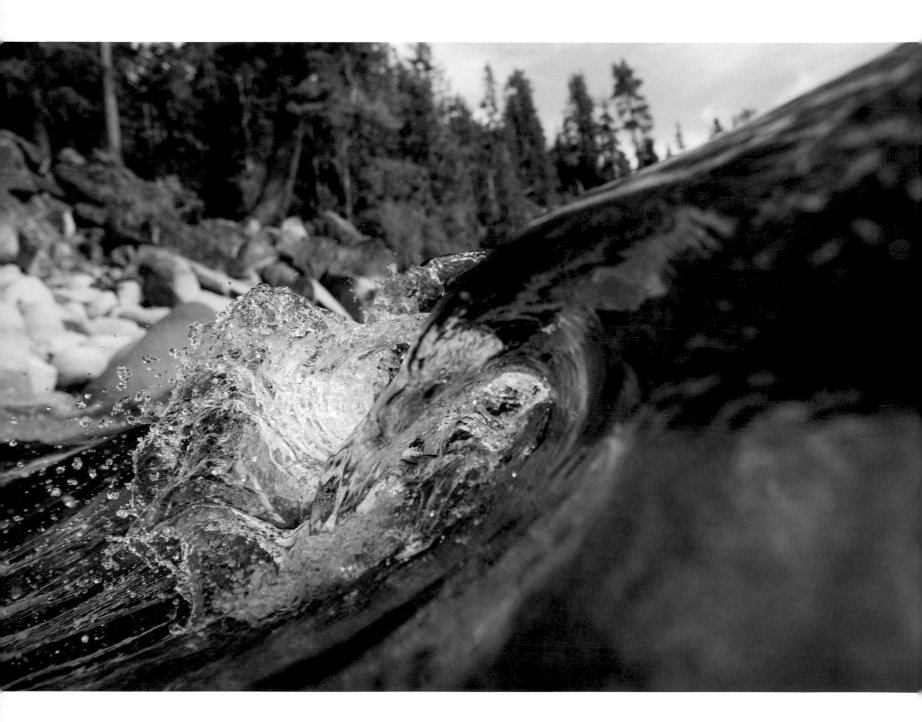

CLARITY

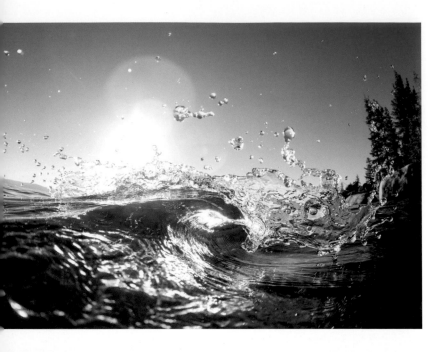
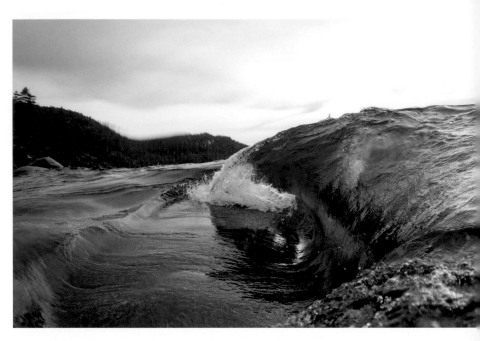
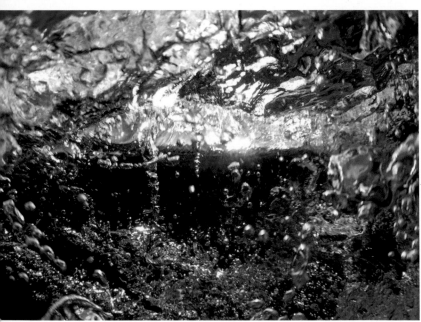
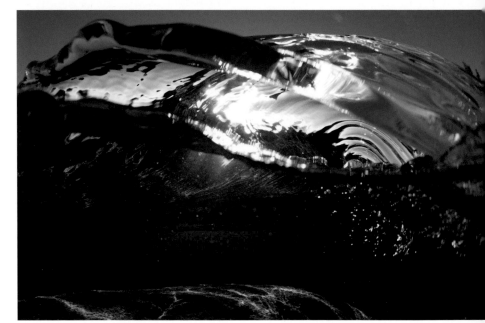

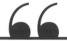

The water is so clear and filled with so much color, it's like splashing liquid glass.

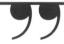

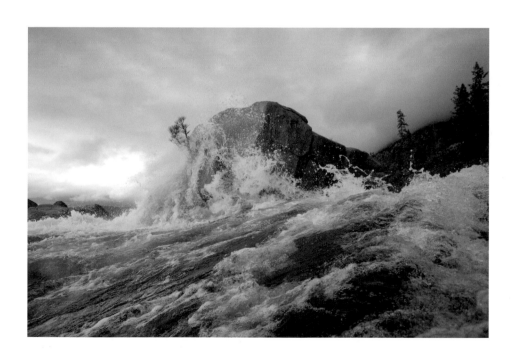

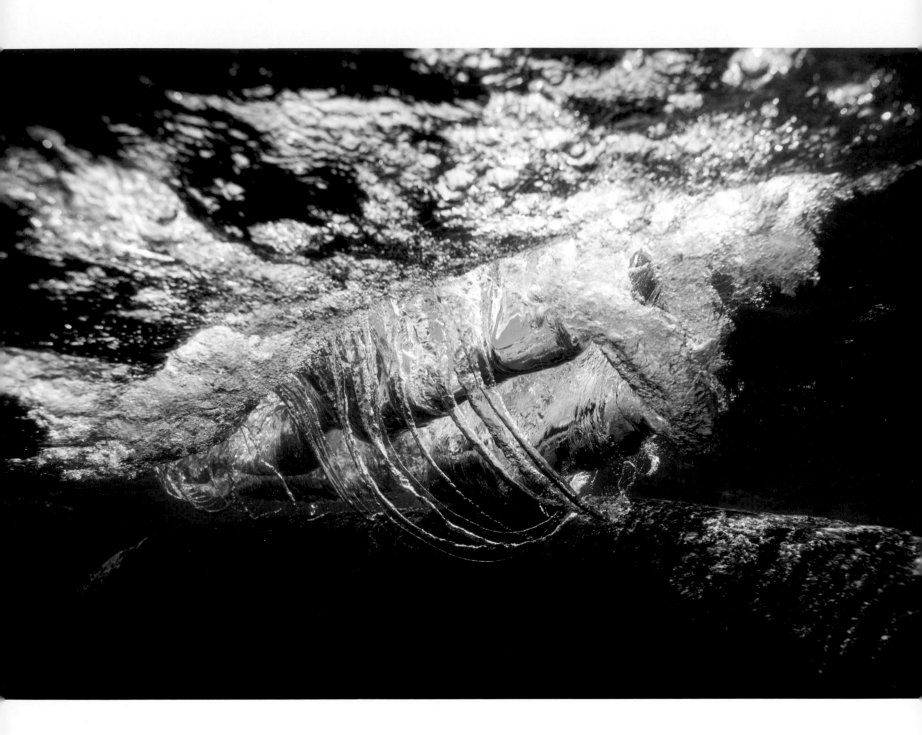

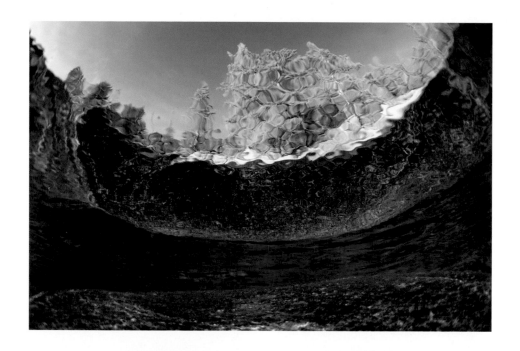

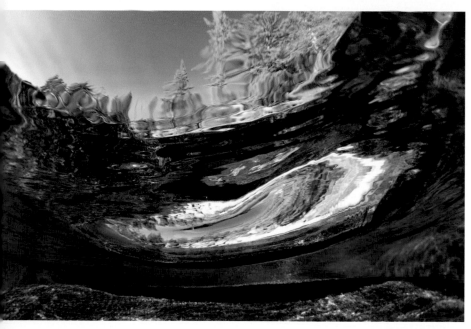

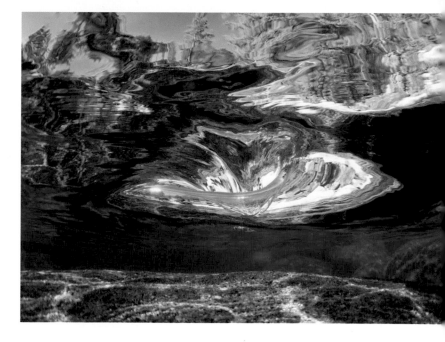

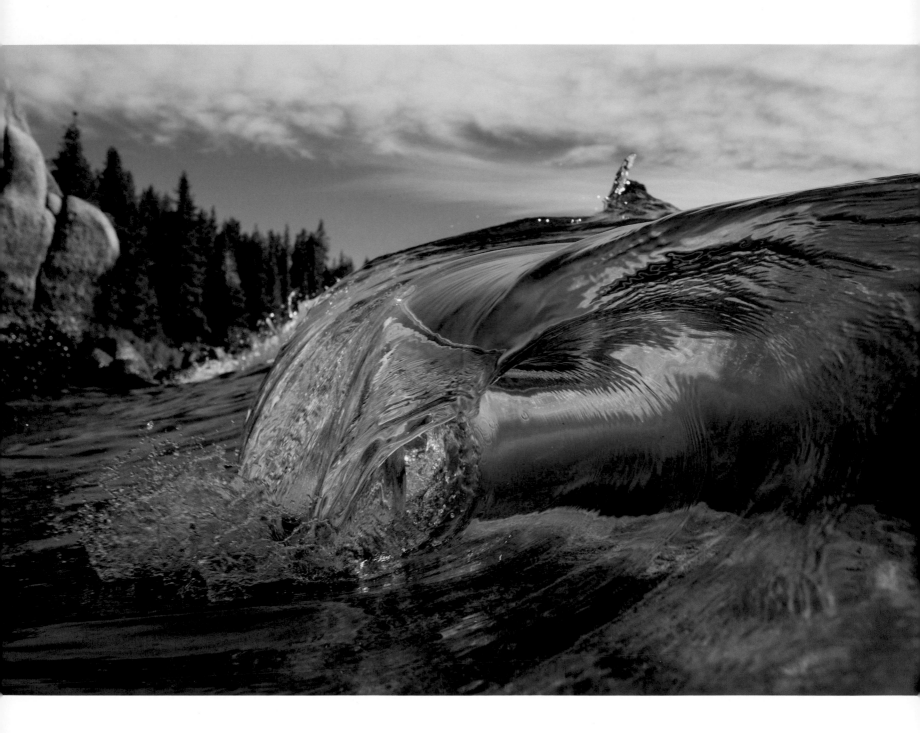

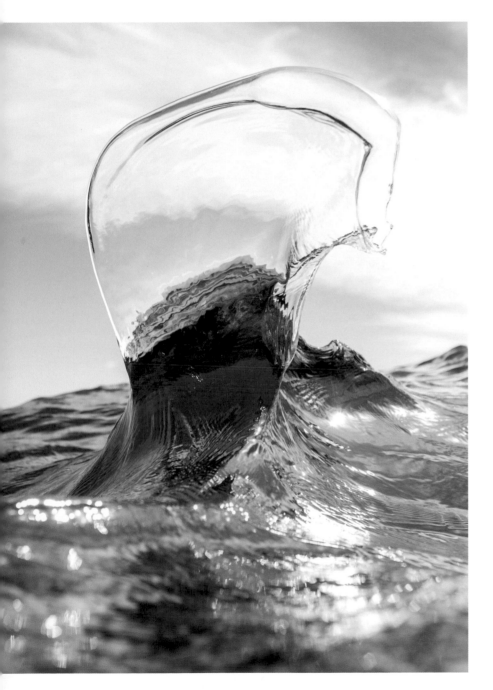
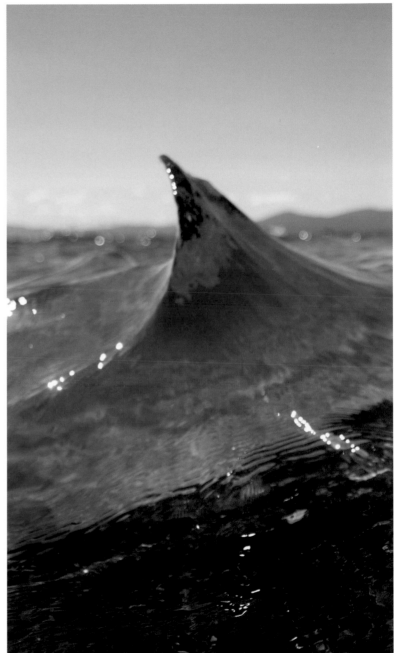

CLARITY

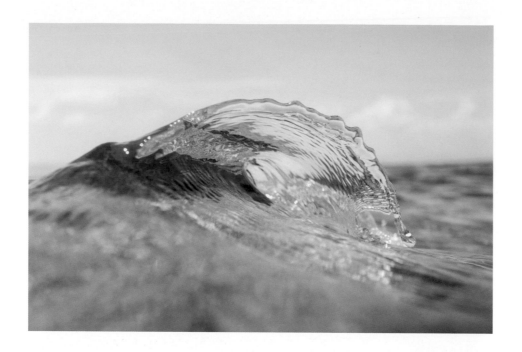

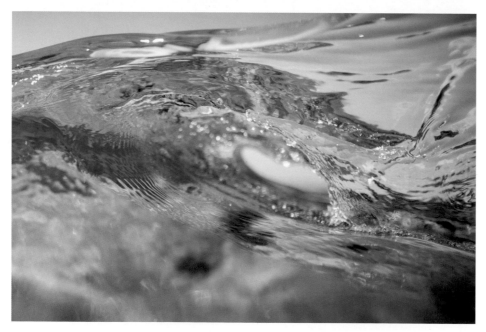

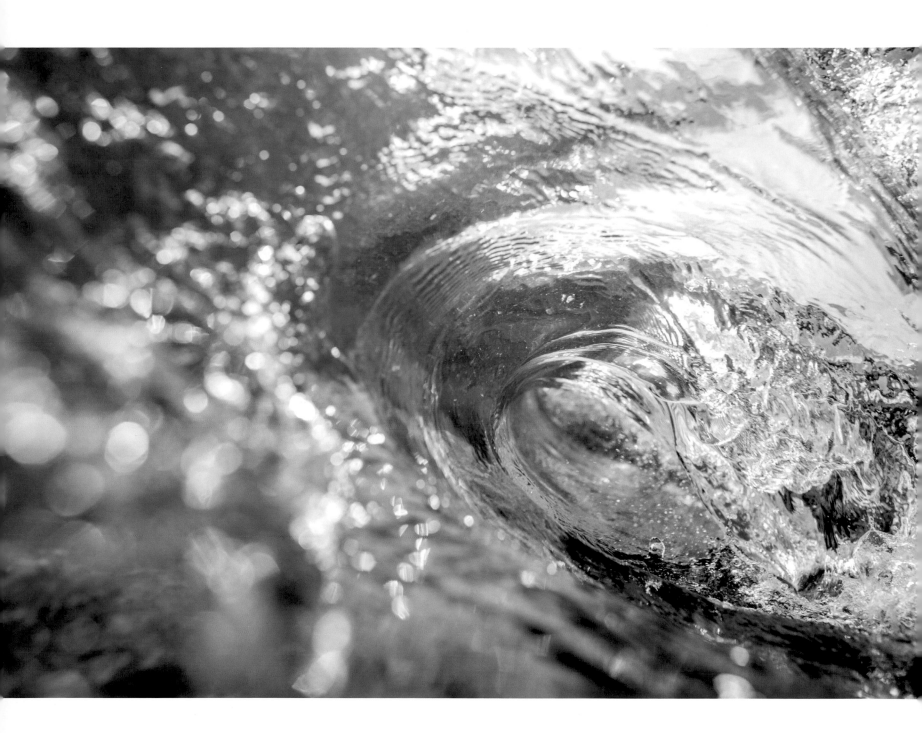

83
CLARITY

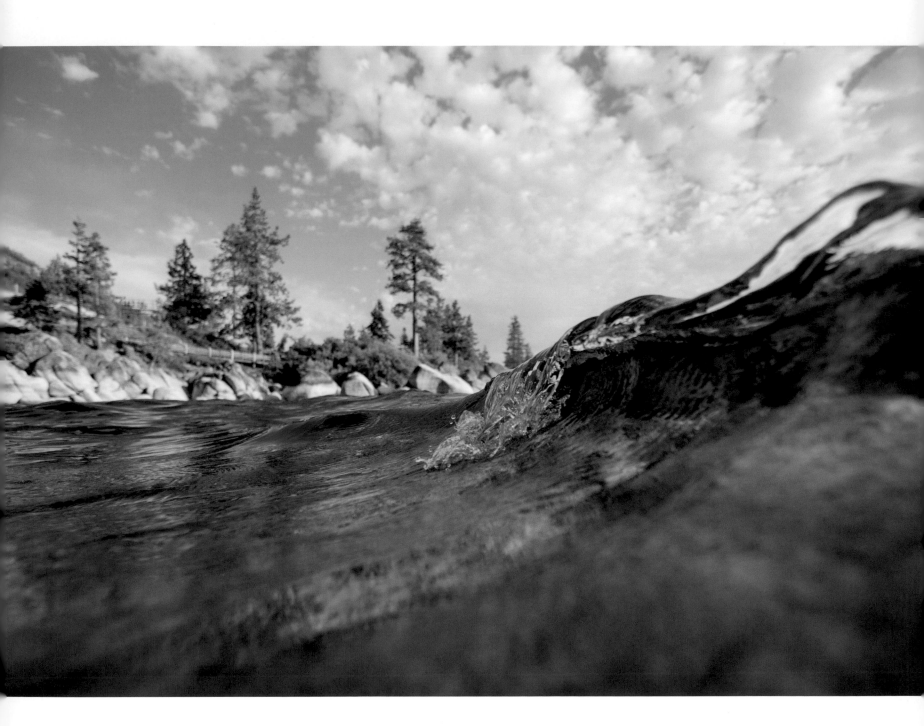

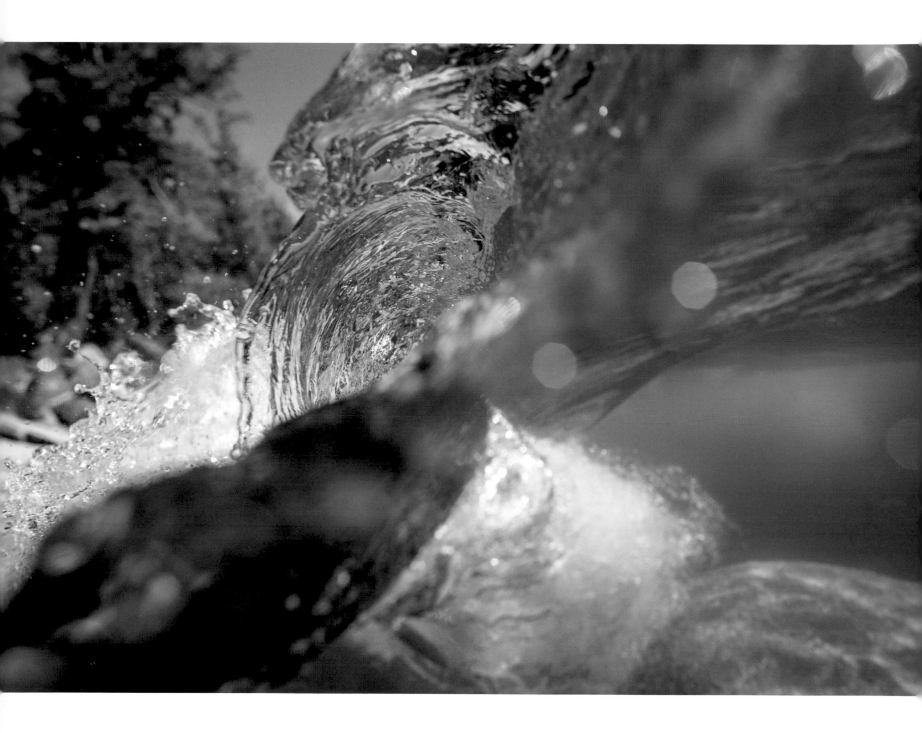

CLARITY

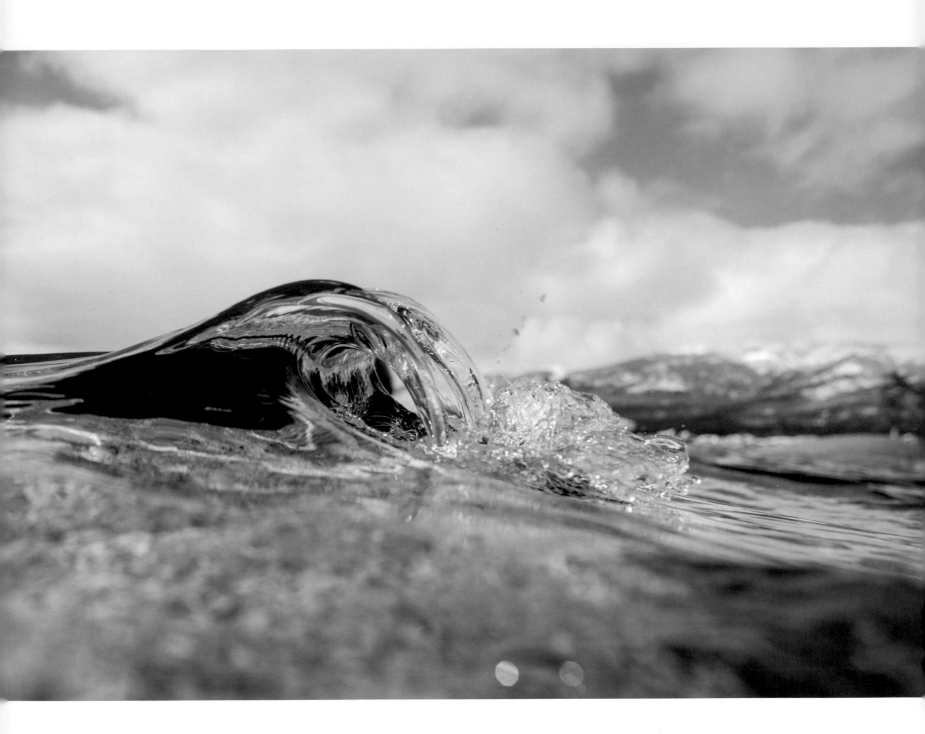

CLARITY

LOOKING UP FROM BELOW

People don't easily forget their first sight of Lake Tahoe. Gripped by its beauty, first-time visitors are known to gaze wide eyed and open mouthed, trying to rationalize the impossibly blue expanse before them. Then again, lifelong residents are no less susceptible to the lake's powers.

The waters of the Jewel of the Sierra have captivated people for generations. They come from near and far to experience Lake Tahoe's natural bounty, from its sprawling shores to its clean mountain air, open skies, and surrounding granite amphitheater. Some arrive for a visit and never leave. Others leave only to return, drawn by the lake's irresistible allure. Those who encounter this alpine wonder often attempt to encapsulate its splendor, to somehow bottle its magic, if only a small piece. But Lake Tahoe's perfection lies only in its wholeness. There is no single vessel or image that can capture its entirety.

Writers try to pen their best descriptions of the lake's rich blue hues. None are wrong and none are right. Emerald, sapphire, cerulean, cobalt, Tahoe's waters are all of these and more. Meanwhile, cameramen rise in the frigid predawn and set out with tripods in tow, intent on capturing the best sunrise there ever was. The possibility, they know, is distinctly real. Mark Twain described Lake Tahoe most fervently and famously in *Roughing It*:

> As it lay there with the shadows of the mountains brilliantly photographed upon its still surface, I thought it must surely be the fairest picture the whole earth affords.

Yet it was another wordsmith of Twain's era who perhaps best captured Lake Tahoe's essence on paper. Naturalist John Muir, founder of the Sierra Club, visited Tahoe in the fall of 1873. After exploring the shoreline by horse, Muir wrote the following in a letter he mailed to a friend:

> Tahoe is surely not one but many. As I curve around its heads and bays and look far out on its level sky fairly tinted and fading in pensive air, I am reminded of all the mountain lakes I ever knew, as if this were a kind of water heaven to which they all had come (*Letters to a Friend*, 1915).

For others, the lake is a source of mystery and intrigue, where a monsterlike creature—Tahoe Tessie—patrols the depths, and a hole links to Nevada's Pyramid Lake through an underground river. Like Twain himself supposedly once said: "Never let the truth get in the way of a good story."

Myths aside, Lake Tahoe is also legendary for serving up recreational fun for children and adults alike. There's something otherworldly about paddling atop a translucent surface, with boulders 20 feet below seemingly within reach. Or diving headfirst into the lake's brisk blue abyss and then air-drying under the warm Sierra sun. Or simply walking along its shore, soaking in the grandeur of the stunning mountain landscape.

Few places on earth offer more everyday treasures. It is a fact not lost on its residents and visitors.

BY SYLAS WRIGHT, EDITOR-IN-CHIEF OF *TAHOE QUARTERLY MAGAZINE*

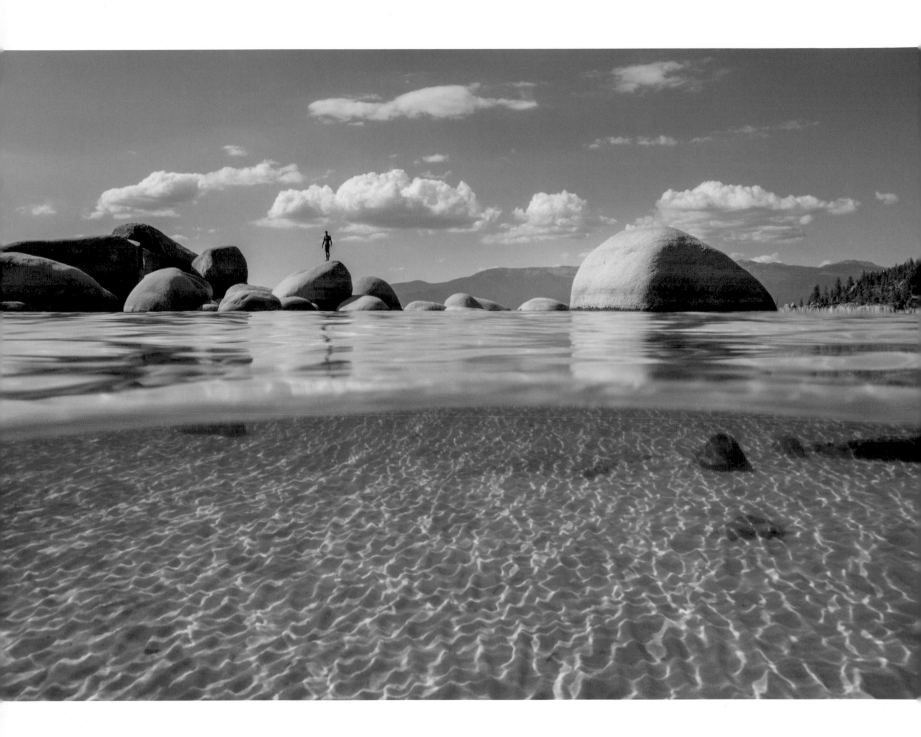

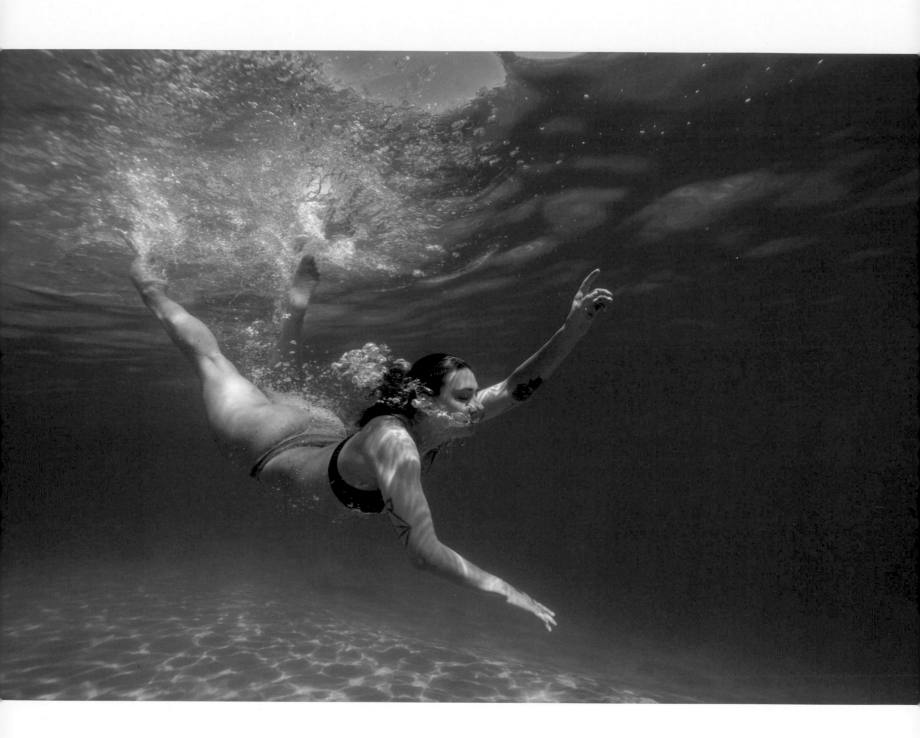

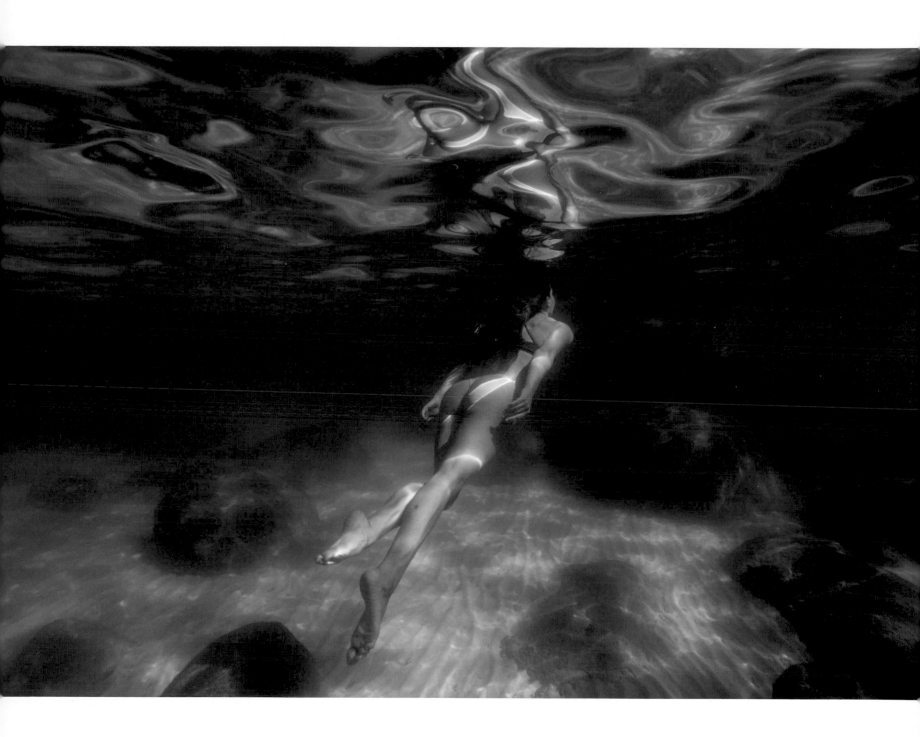

CLARITY

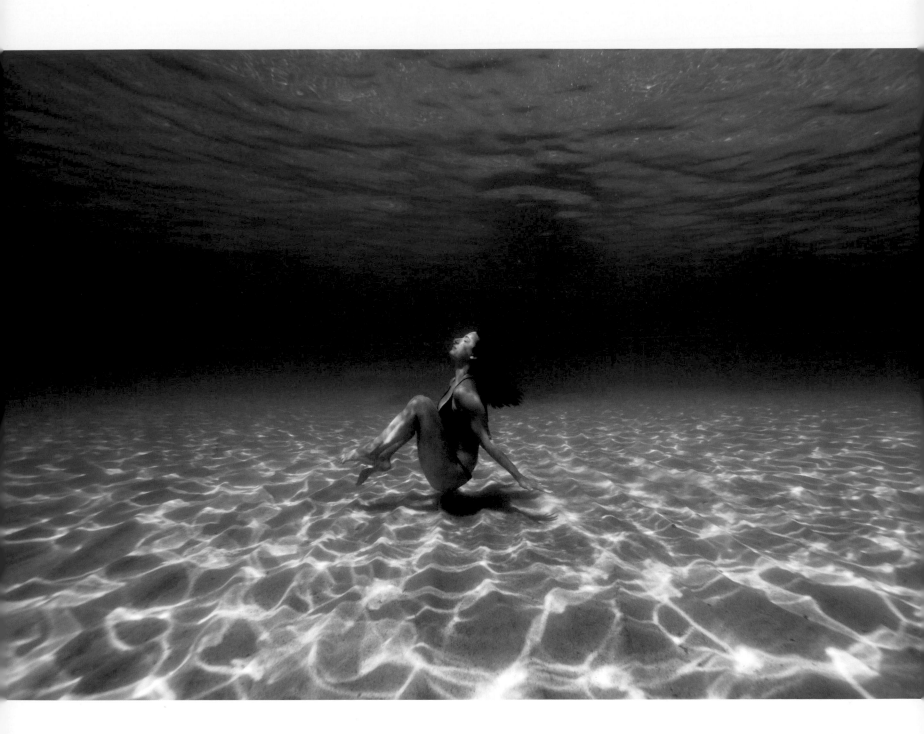

CLARITY

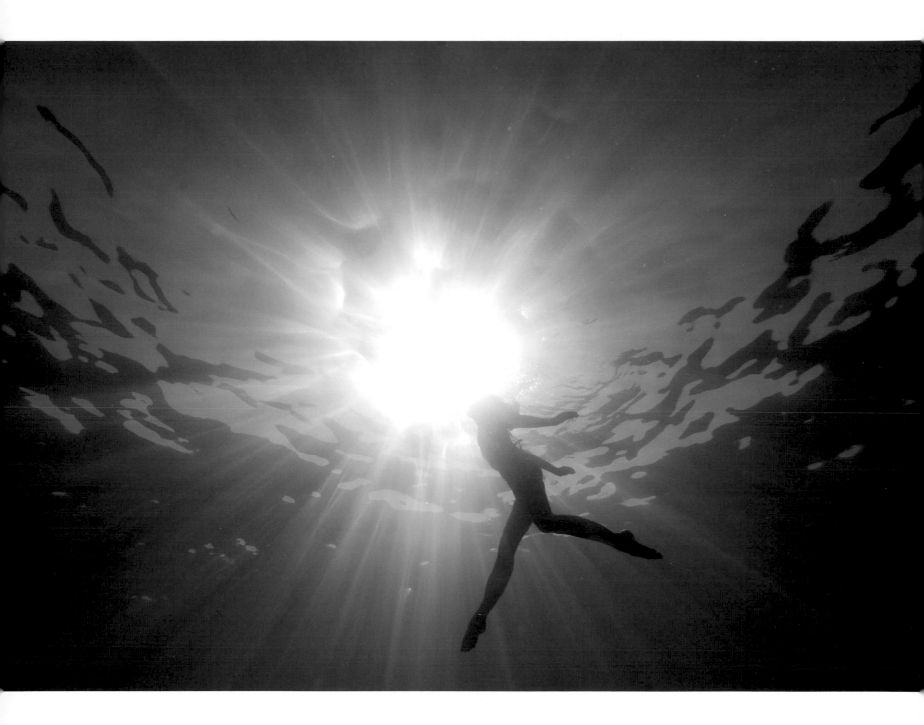

CLARITY

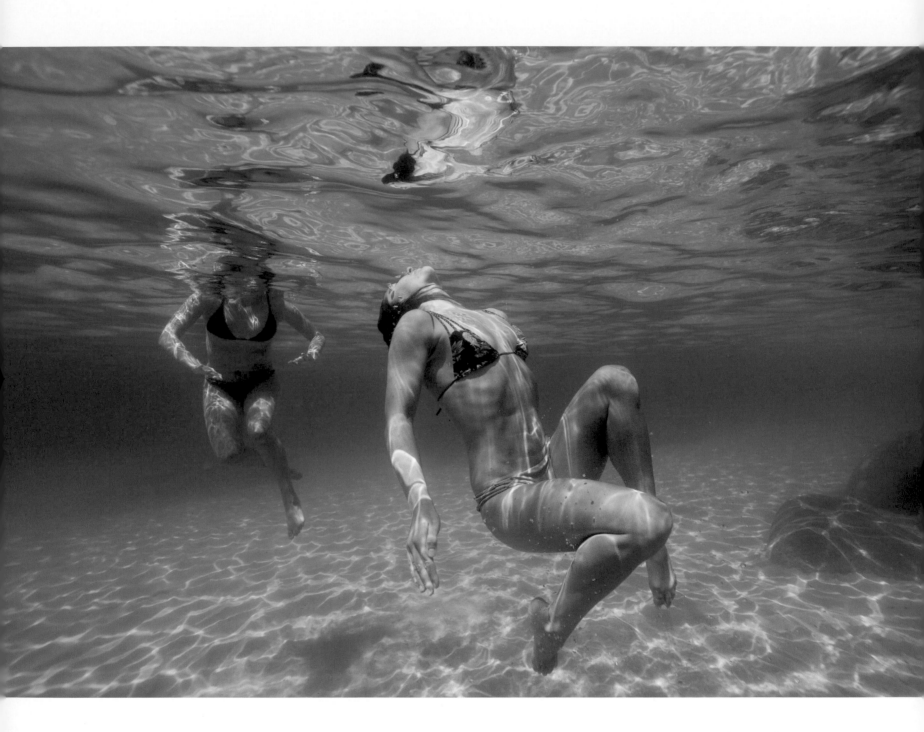

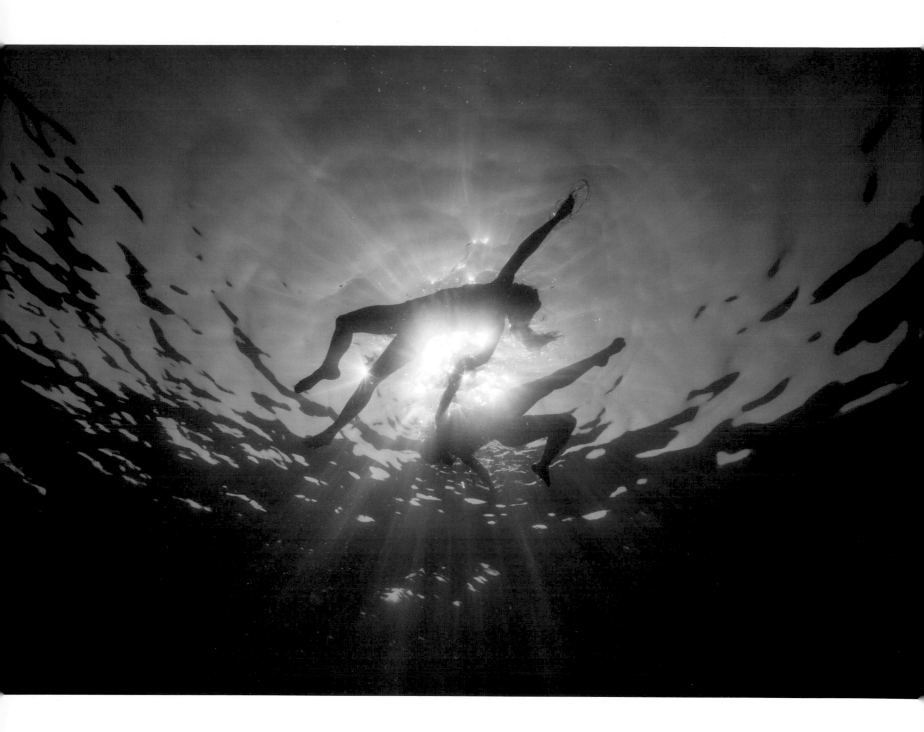

CLARITY

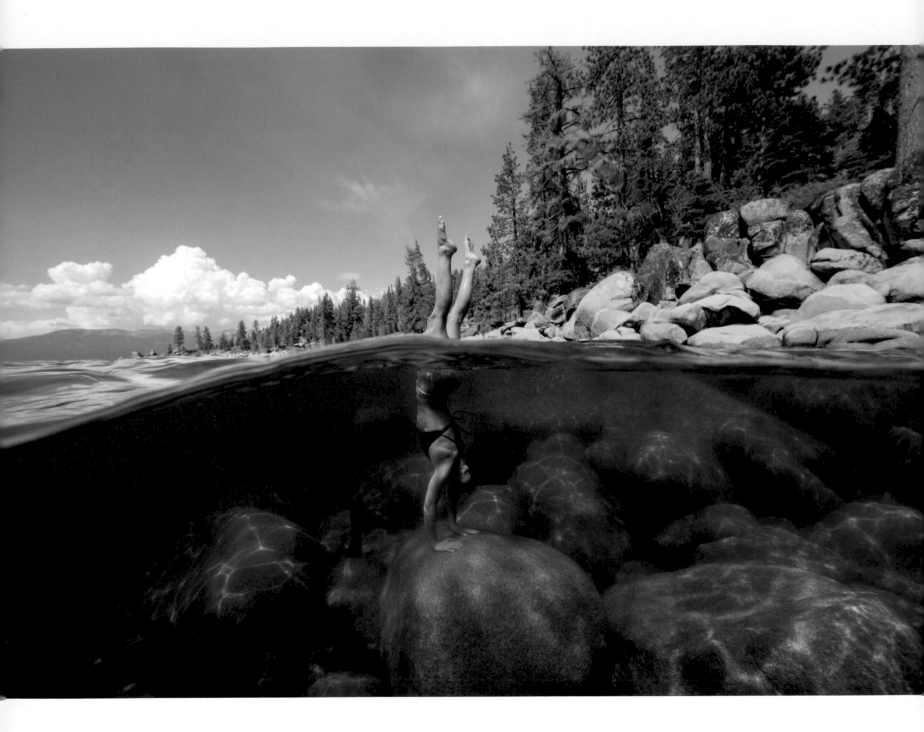

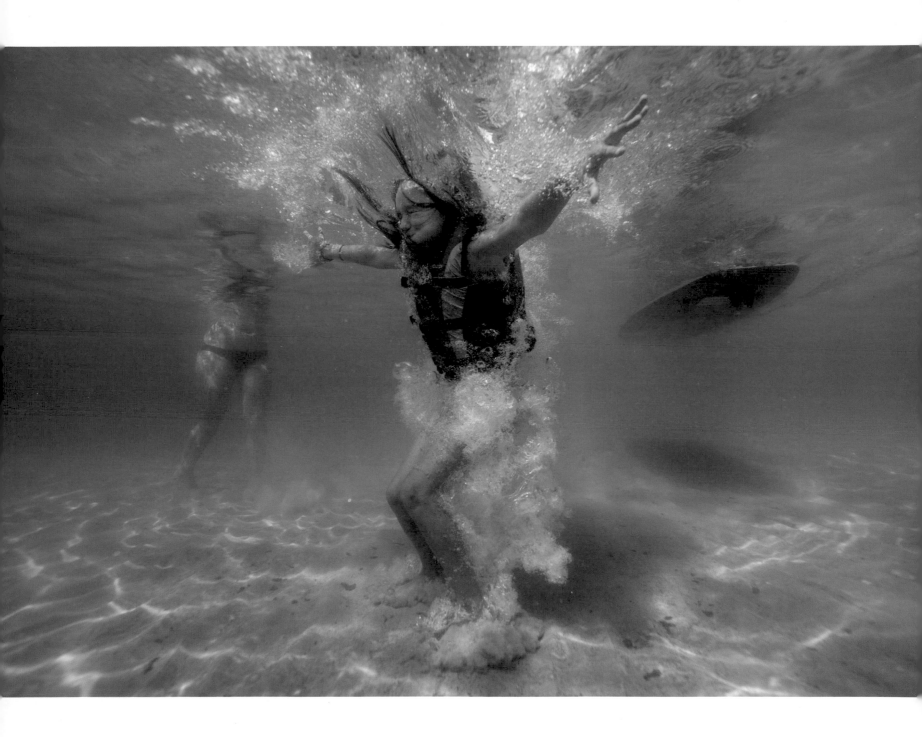

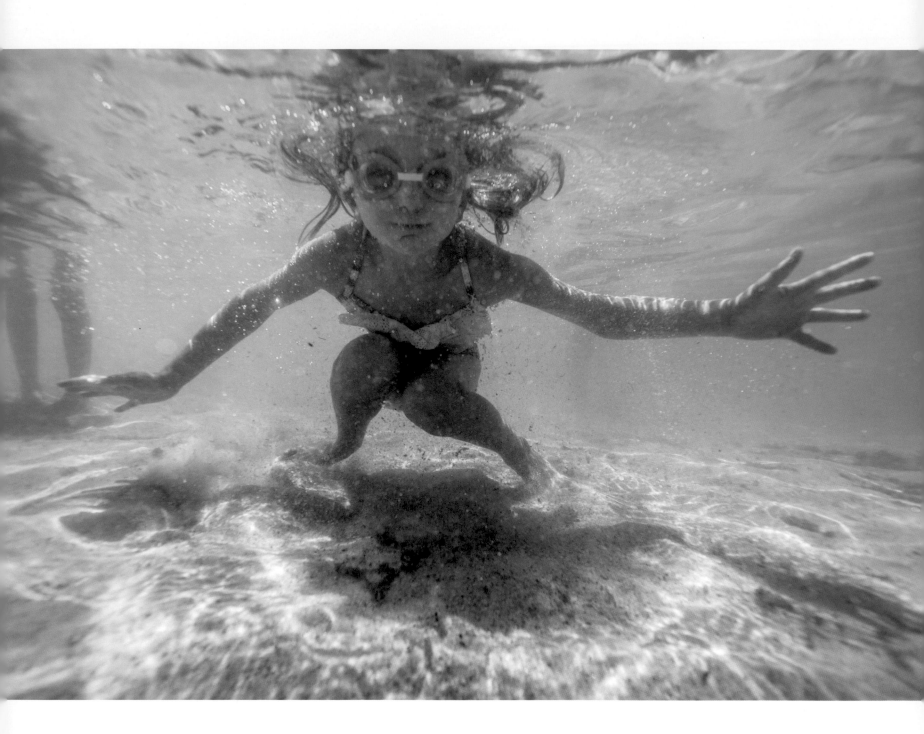

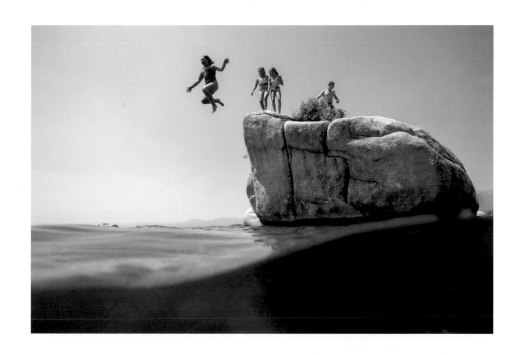

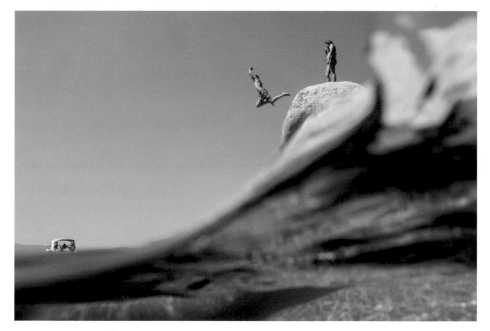

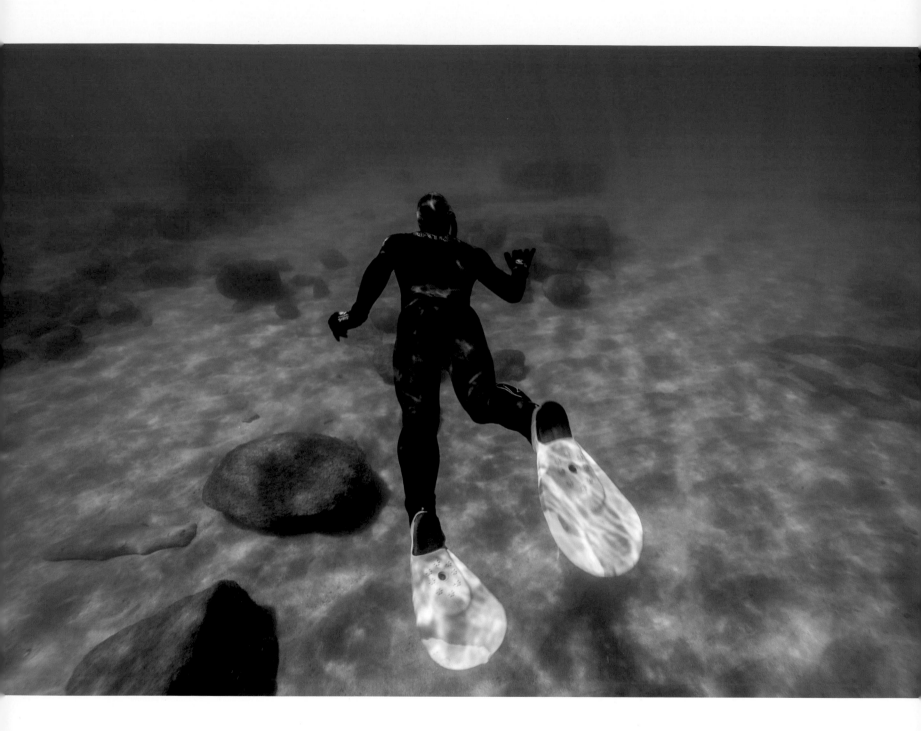

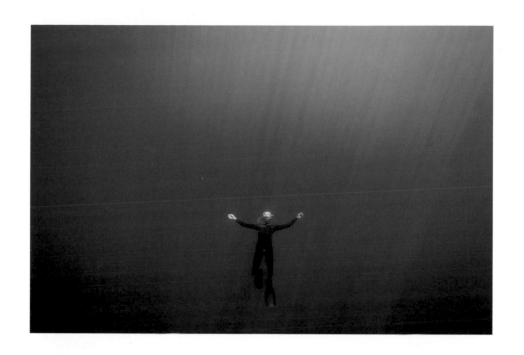

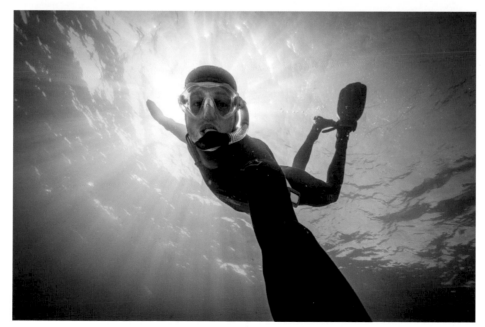

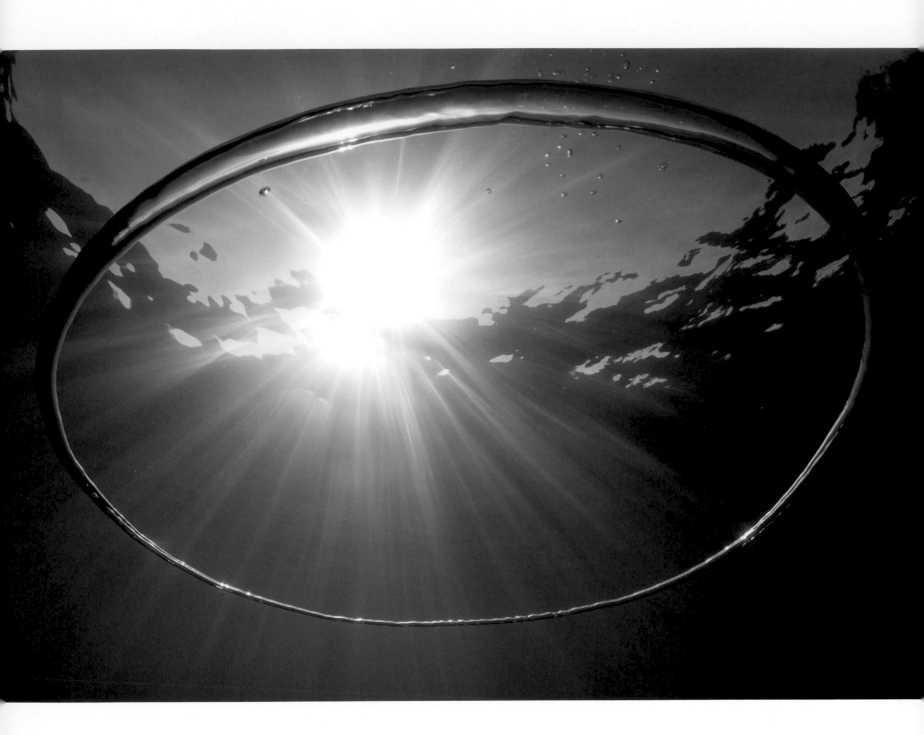

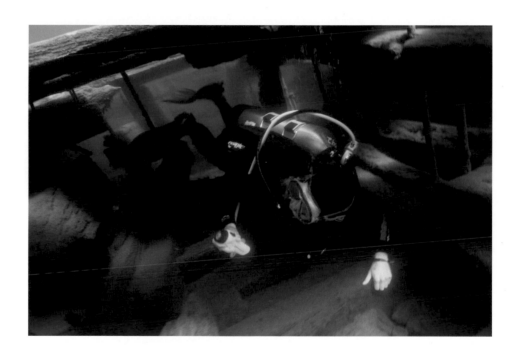

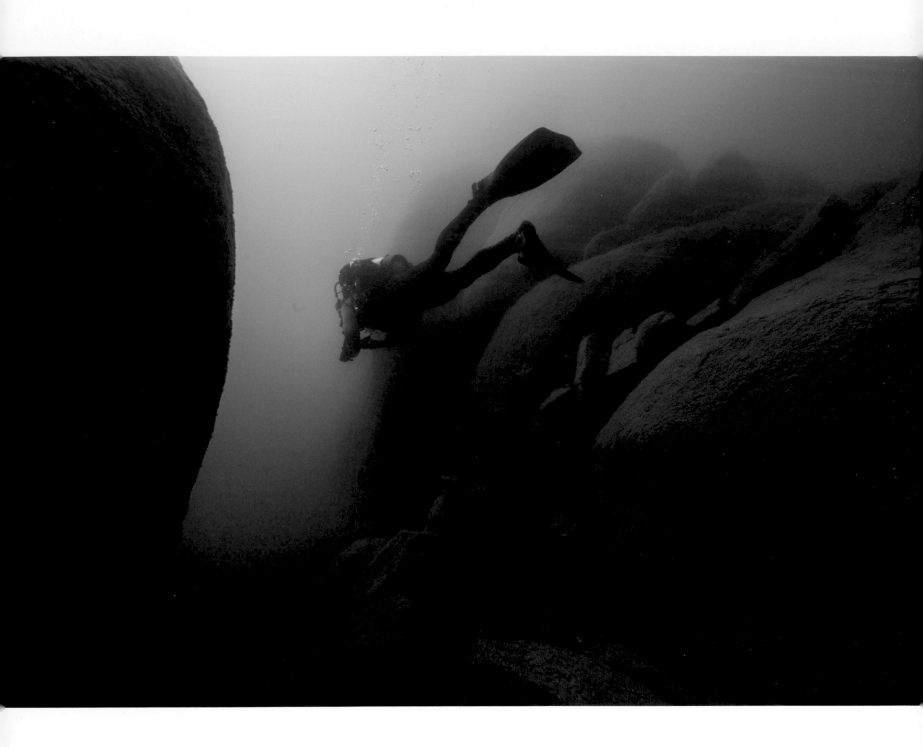

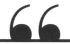

I am reminded of all the
mountain lakes I ever
knew, as if this were a kind
of water heaven to which
they all had come.
—John Muir

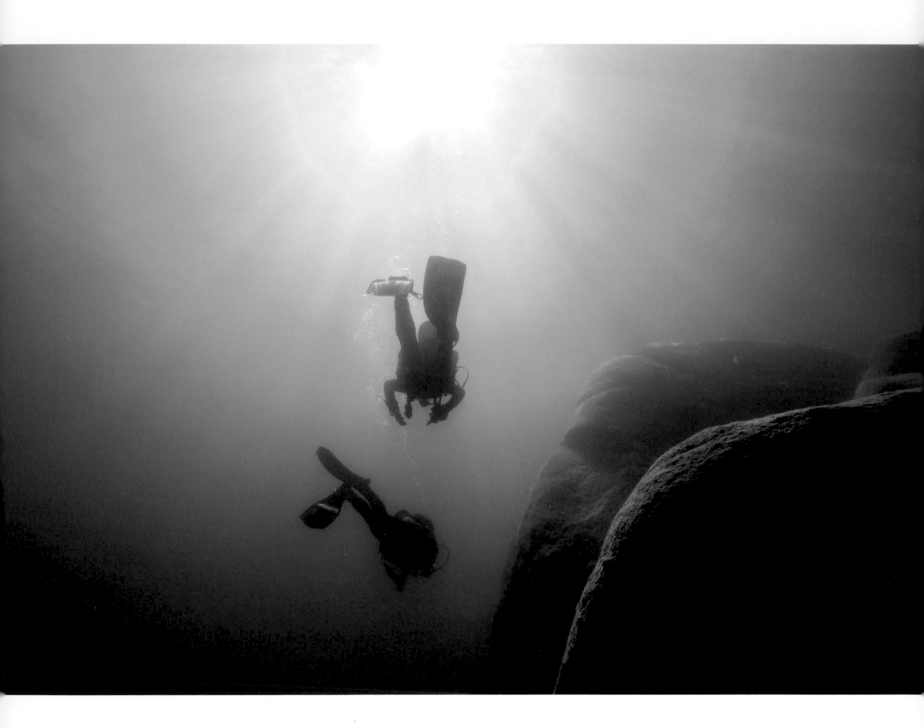

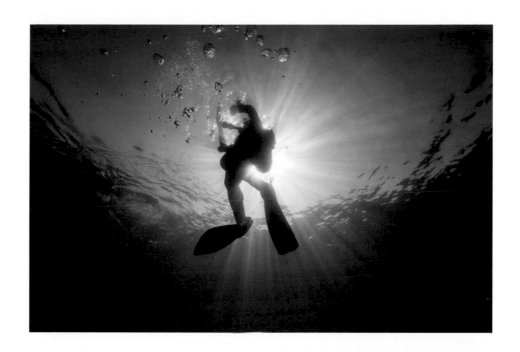

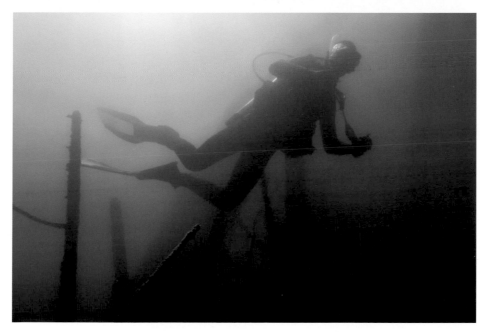

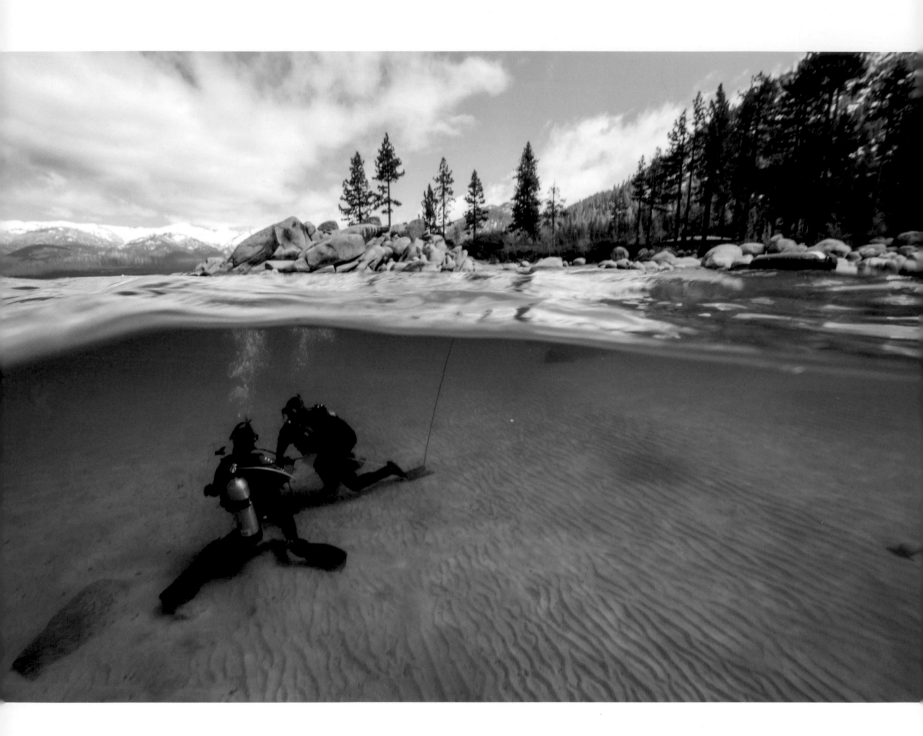

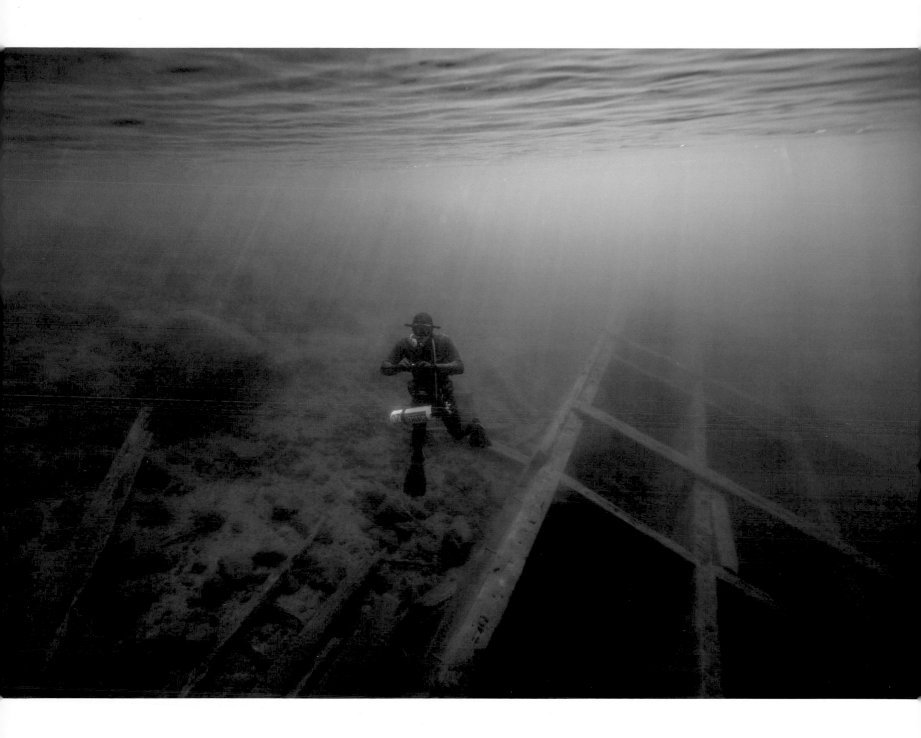

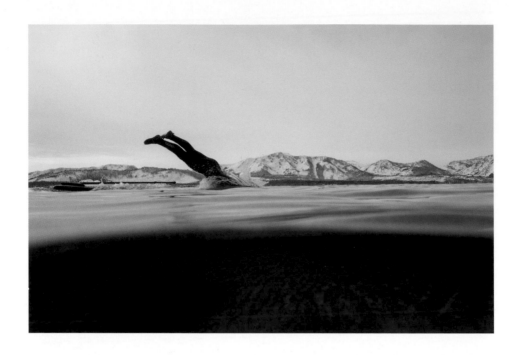

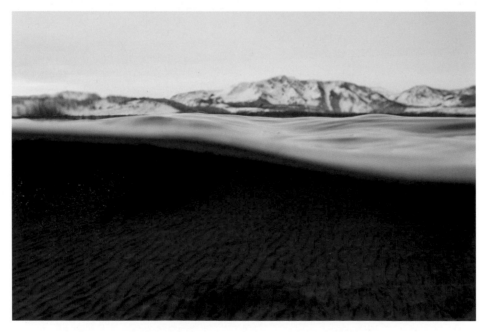

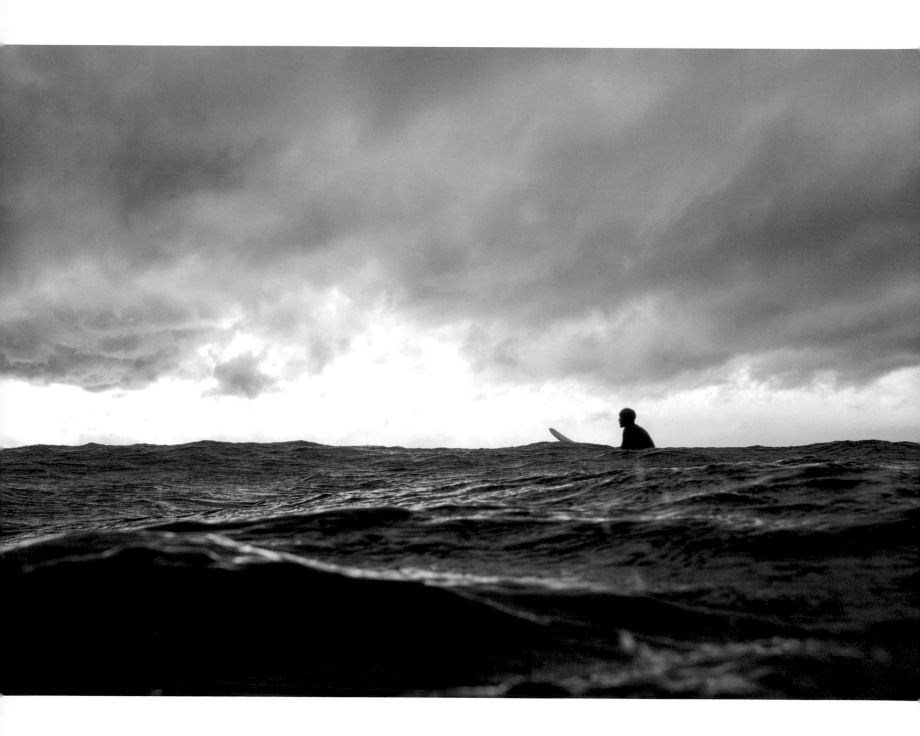

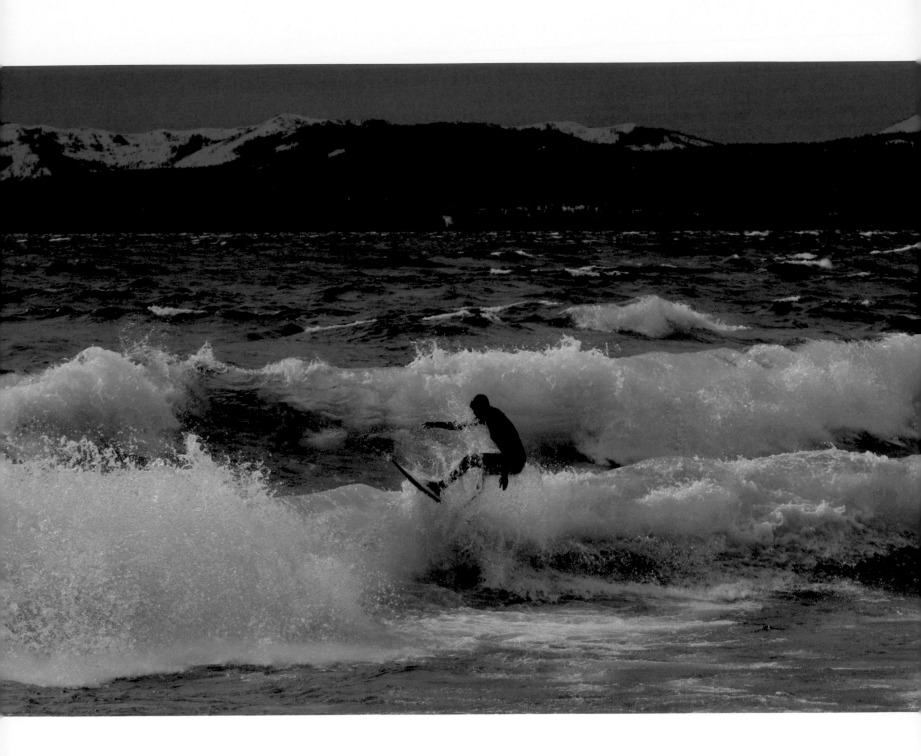

CLARITY

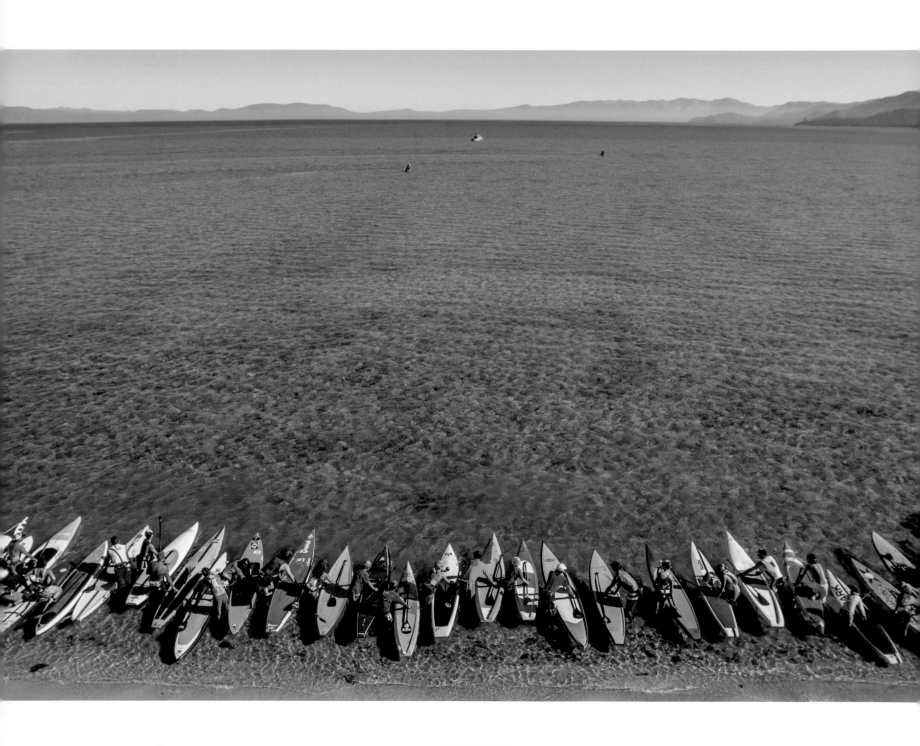

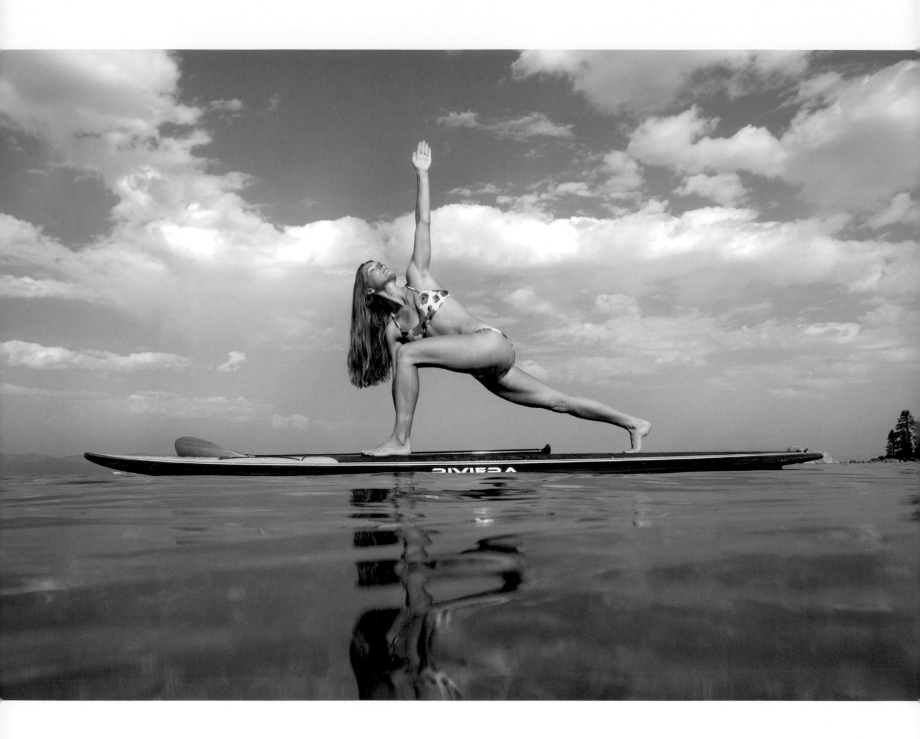

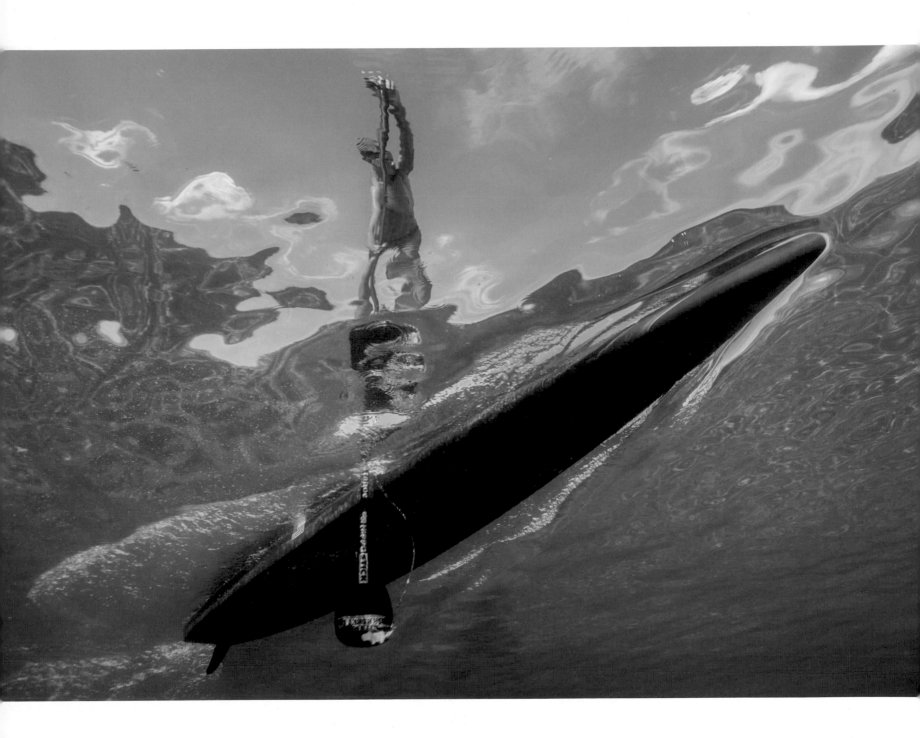

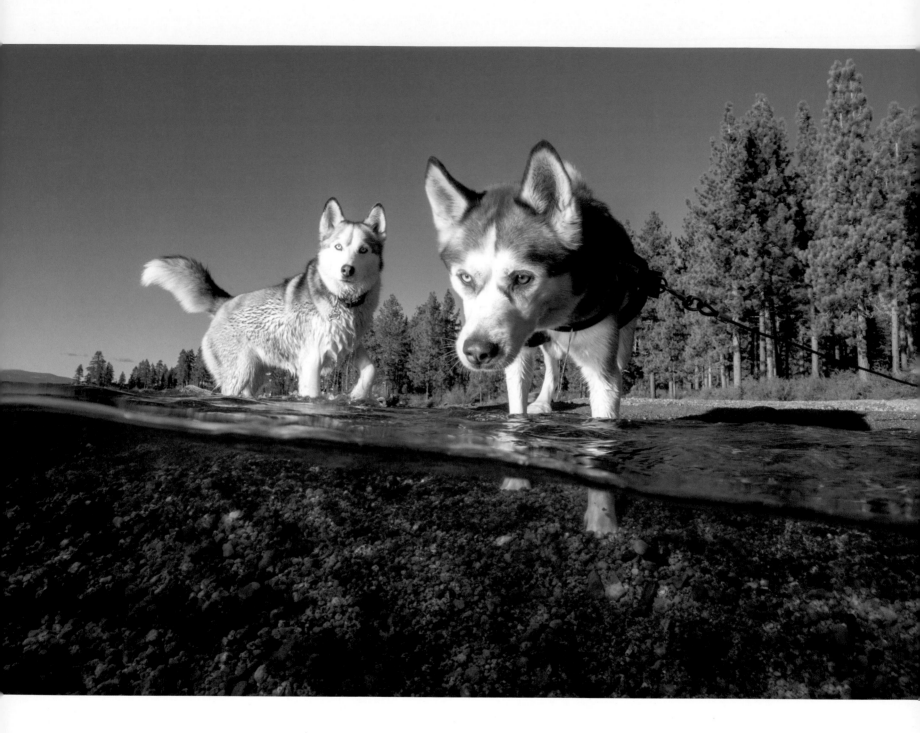

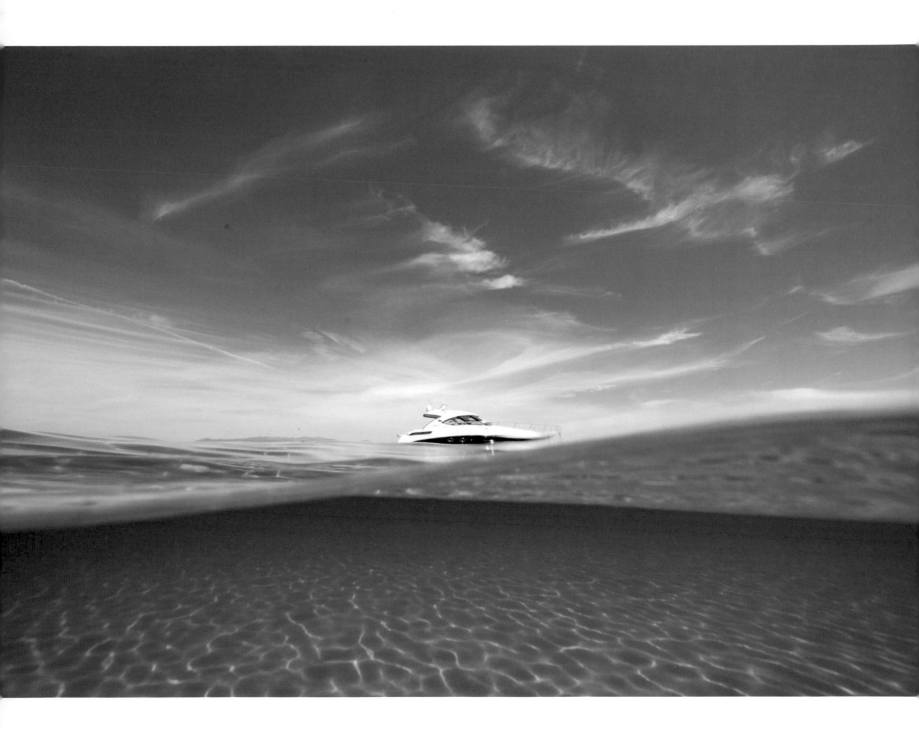

HIDDEN IN THE BLUE

I've always been fascinated with things lost underwater. And there are a lot of lost items in Lake Tahoe. Evidence of hundreds of years of habitation in the surrounding mountains and shoreline lies scattered on the sand, some of it too deep to ever reach. On every swim and every dive, a little nudge of curiosity propelled me deeper, into dark holes between boulders and over the edge of sloping drop-offs. I knew that at any moment in almost any location, I might come across sunken treasure.

I never found gold bullion or silver coins. I didn't stumble into a suitcase full of money. But I frequently came across items that spurred my imagination, not only the man-made relics of the past, but also animals, plants, and natural debris that hinted at an evolution too grand for human comprehension.

In this chapter, you'll find images of sunken barges, old foundations, and railroad tracks that were once used to roll boats in and out of the water. There are images of freshwater sculpin and thick schools of minnows that inhabit the diveable zone. You'll see common animals and one of the several grounded sailboats I encountered. Here too are photos of the most common things I'd find underwater: bottles and cans.

Unfortunately, among all the amazing artifacts hidden in the blue, there's a lot of garbage. It's no surprise. Lake Tahoe was once used as a dumping ground for anything and everything. Now, beverage containers, plastic bags, old clothes, plasticware, engine blocks, buckets, fishing line, plastic wrap, and plastic bits and pieces are impossible to avoid. I can't remember a single swim or dive on which I didn't find trash. It's an overwhelming issue that no one understands entirely.

Some of the things I found underwater were not intended to end their life listing in the granite sand beneath Tahoe's surface. There are cameras, sunglasses, car batteries, cell phones, and jewelry. There are boats and boating equipment, and by some reports even an old Model A Ford. I found a drone, a bong, and three $20 bills. In more than 200 days in the lake, I saw a few trout but rarely got close enough for good photos.

My most memorable find, though, had to be in the southwest corner of Emerald Bay. A hundred yards offshore, a tangle of logs stick up out of the water. Underwater, it's a sunken forest, with trees 2 feet in diameter slanting down into the soft earth bottom. Everything is coated in a fine silt, and algae hangs from the branches. With rays of sun beaming through the trunks, it's a surreal scene. I'm by no means the first to explore here, but of all my plunges into Lake Tahoe, it was eerie, exhilarating, and, I believe, the closest I came to finding that mythical sea creature that lives somewhere in the blue.

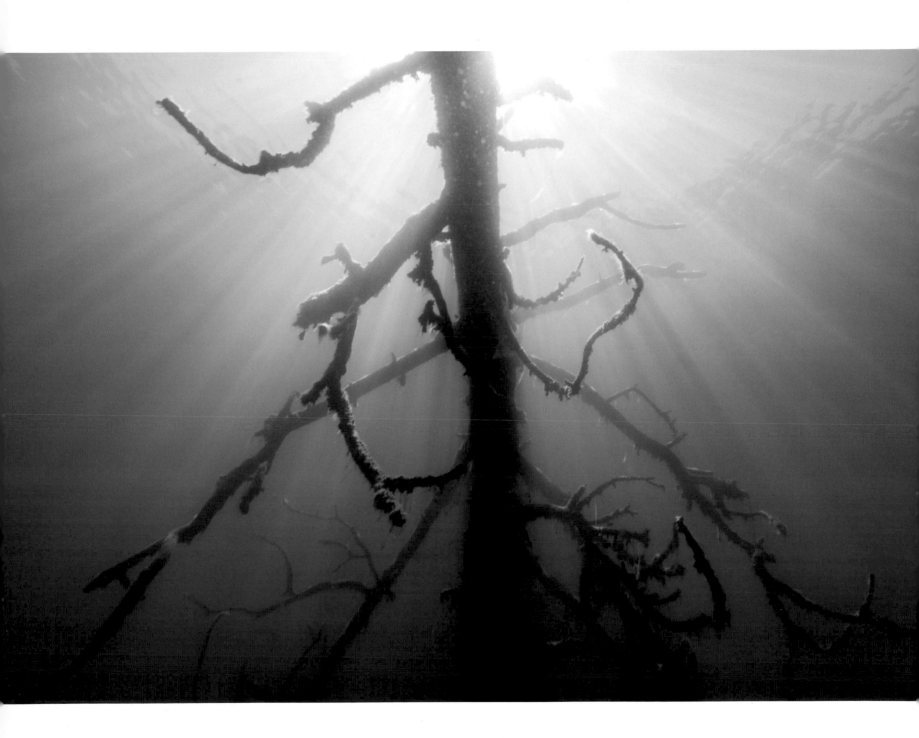

CLARITY

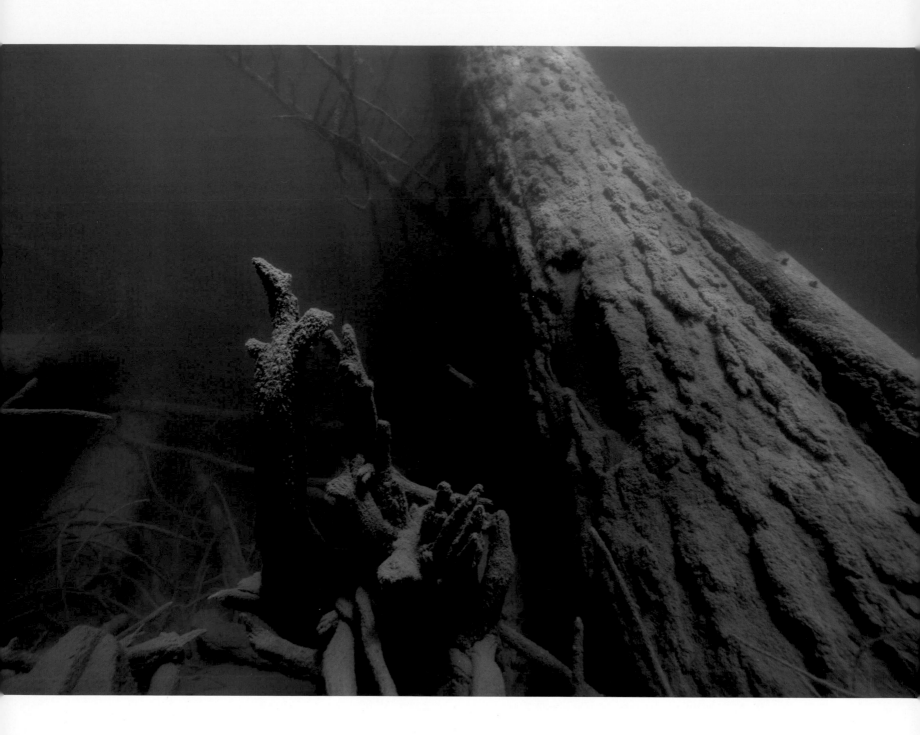

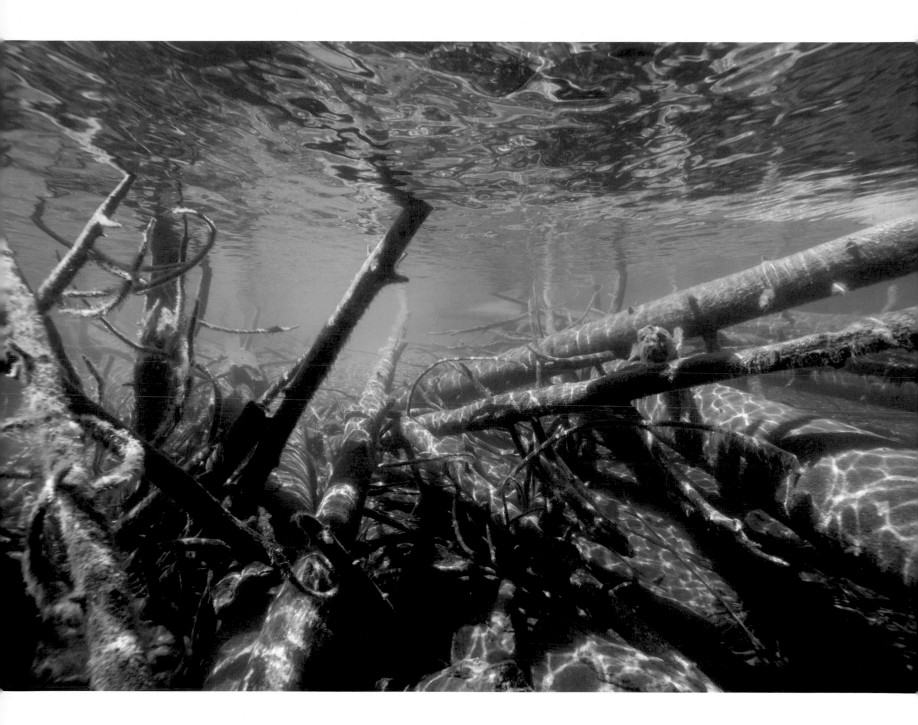

CLARITY

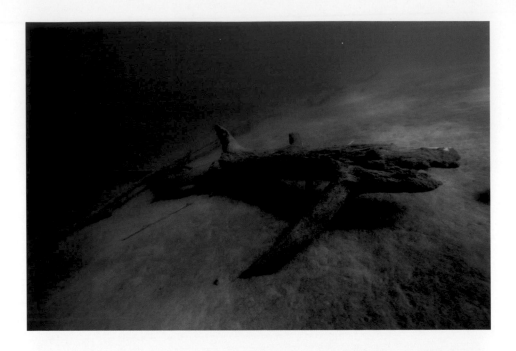

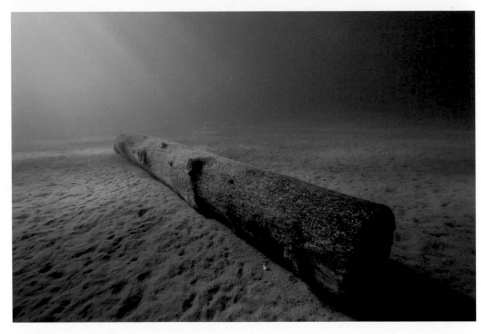

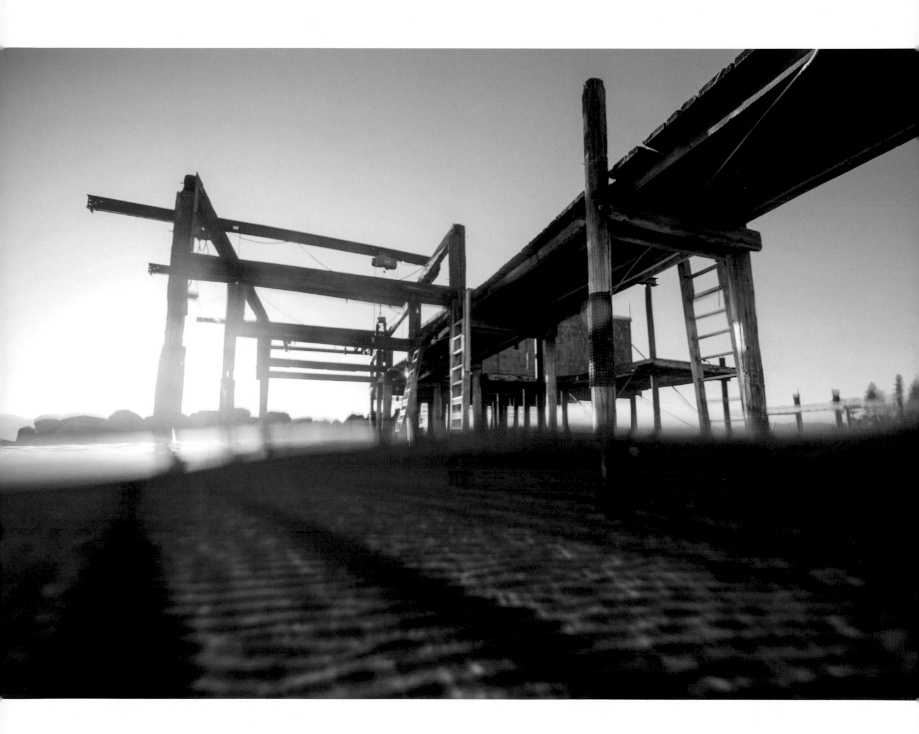

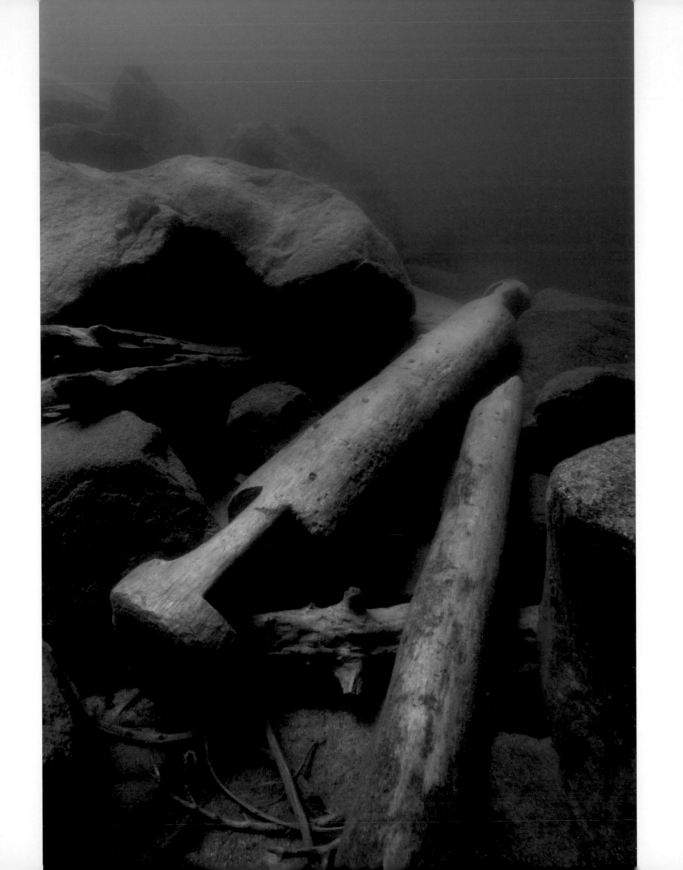

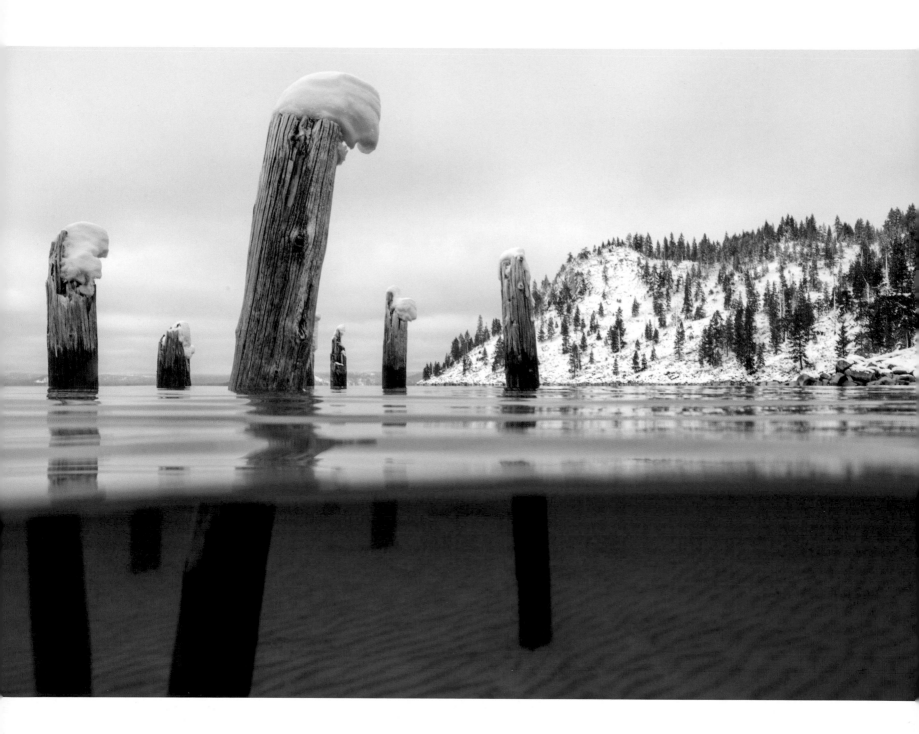

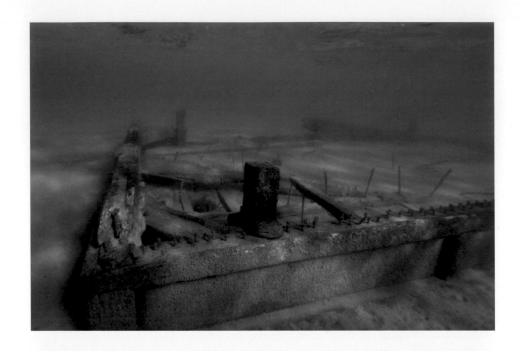

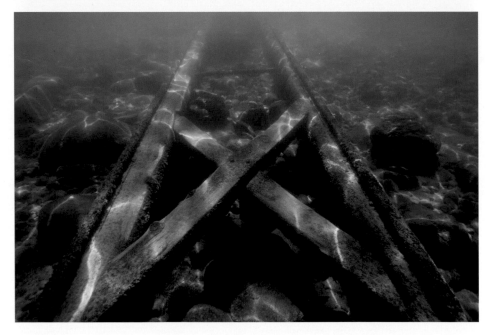

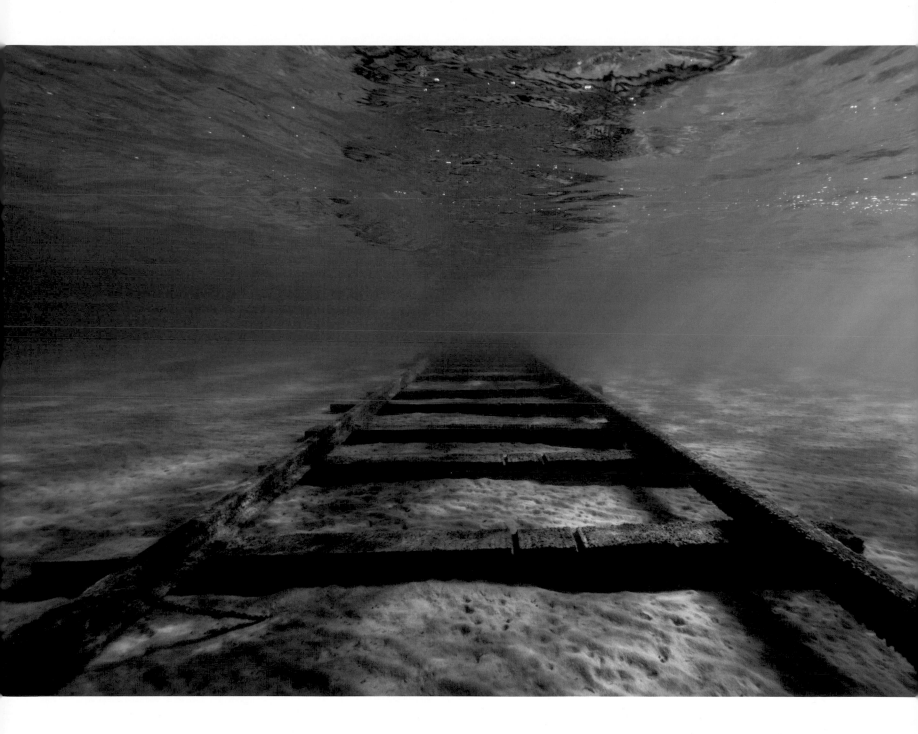

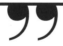

On every swim and every dive, a little nudge of curiosity propelled me deeper. . .

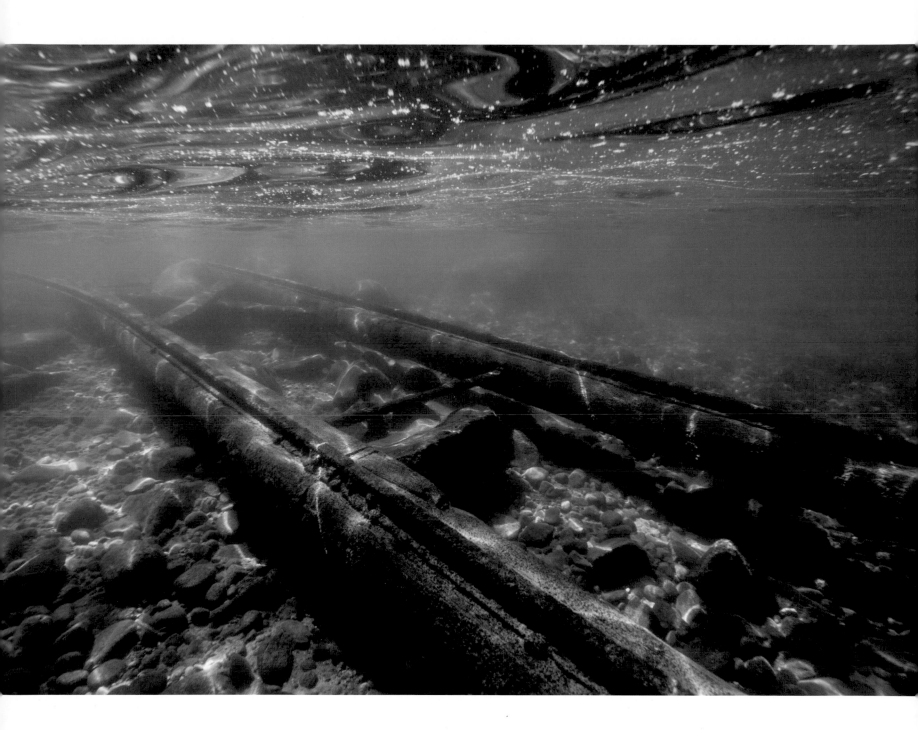

CLARITY

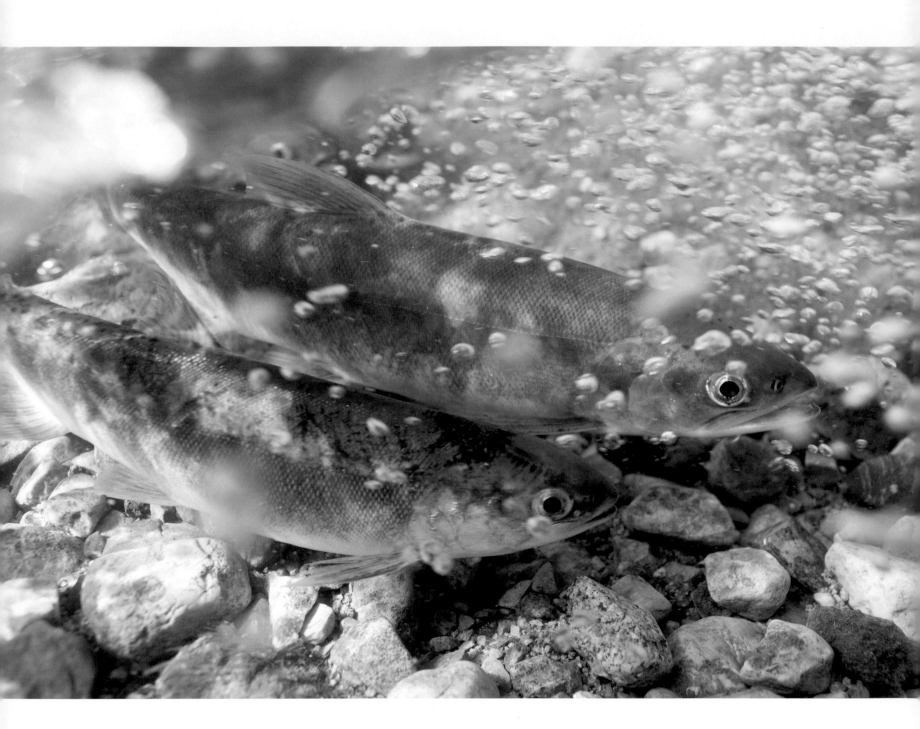

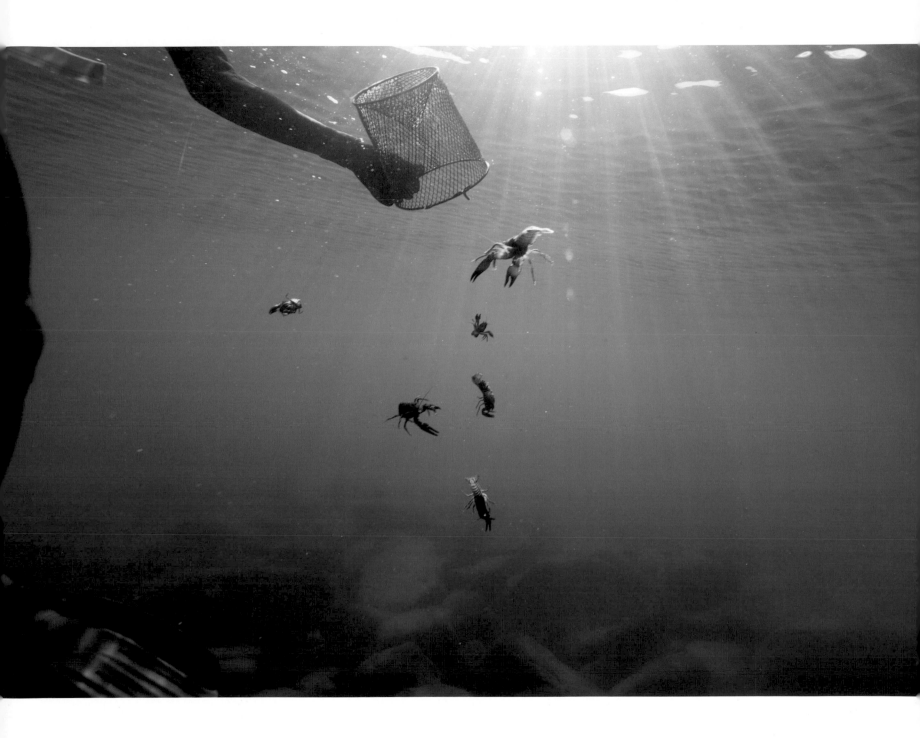

CLARITY

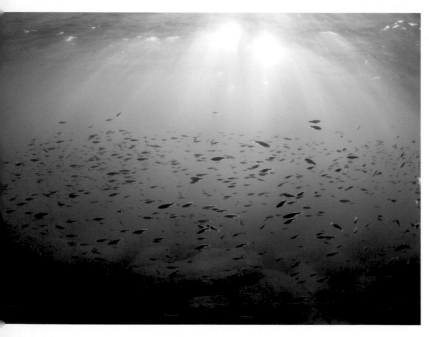

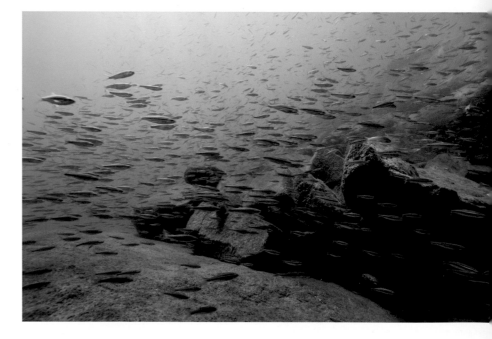

CLARITY

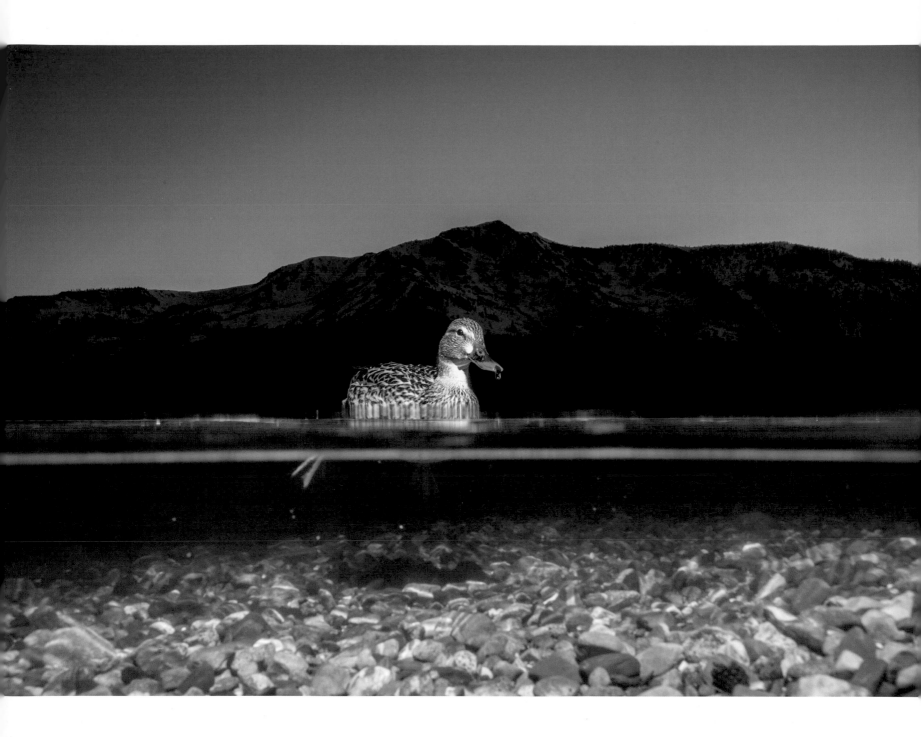

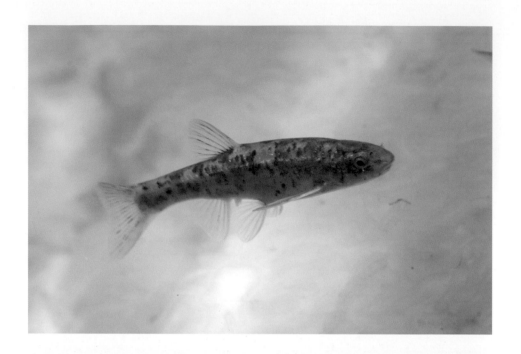

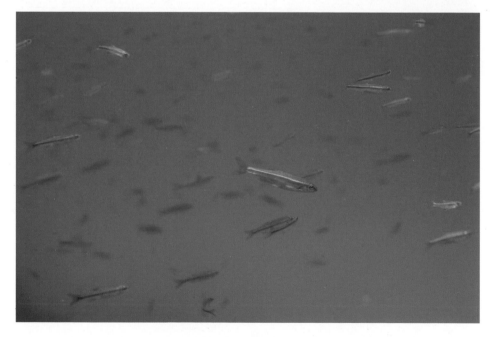

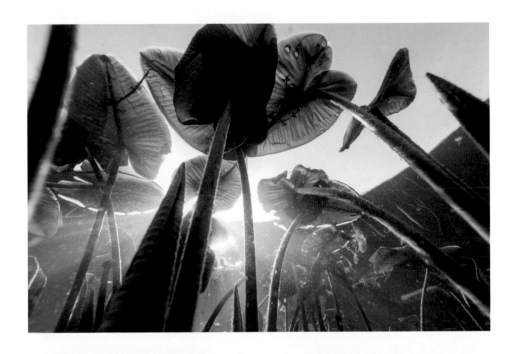

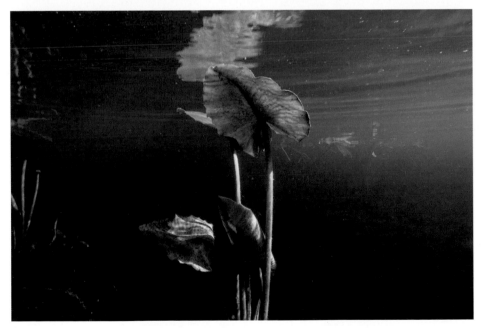

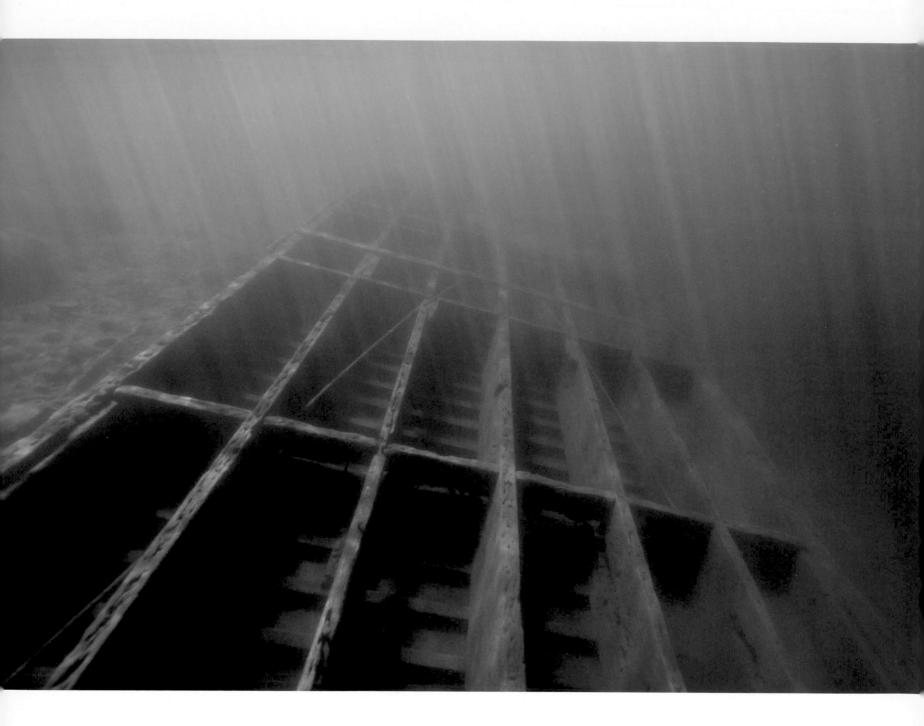

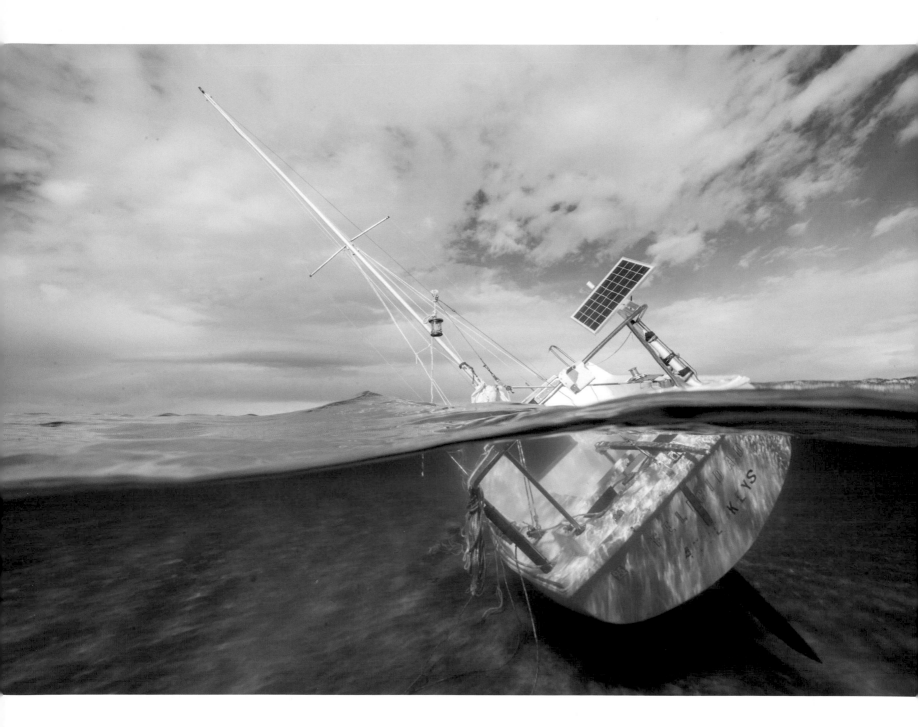

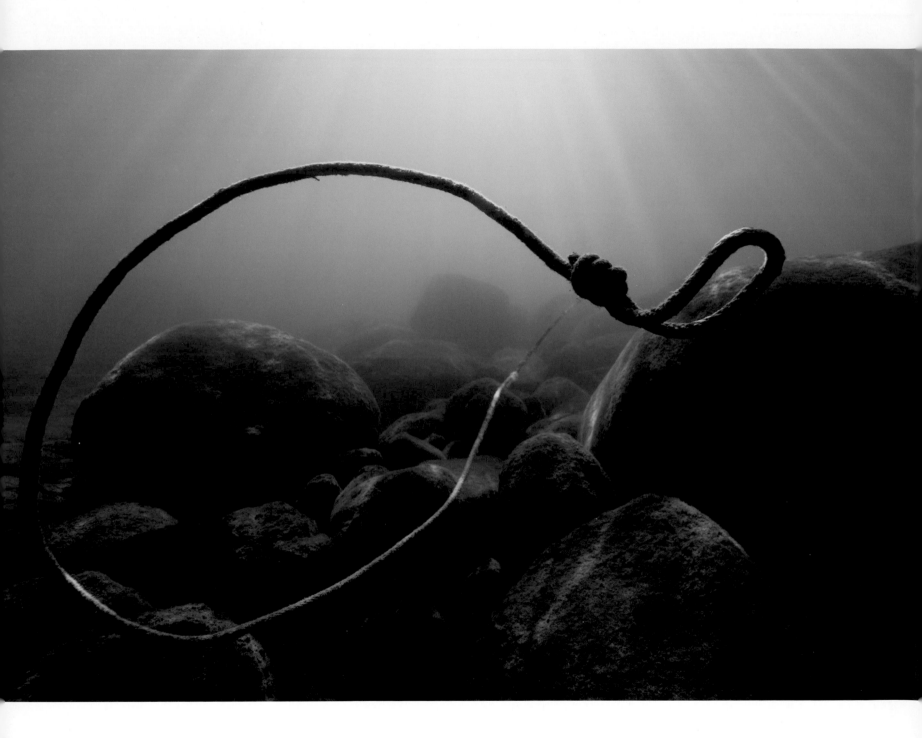

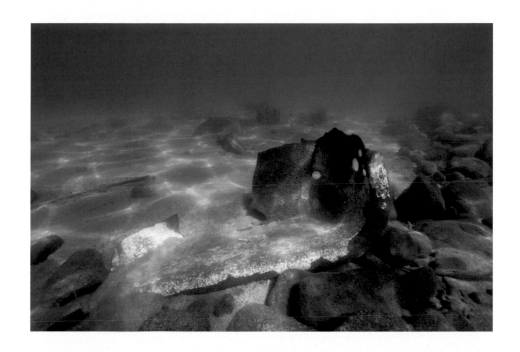

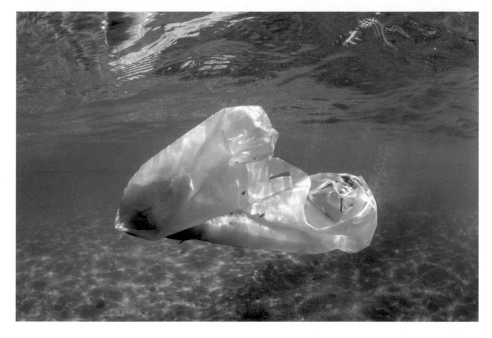

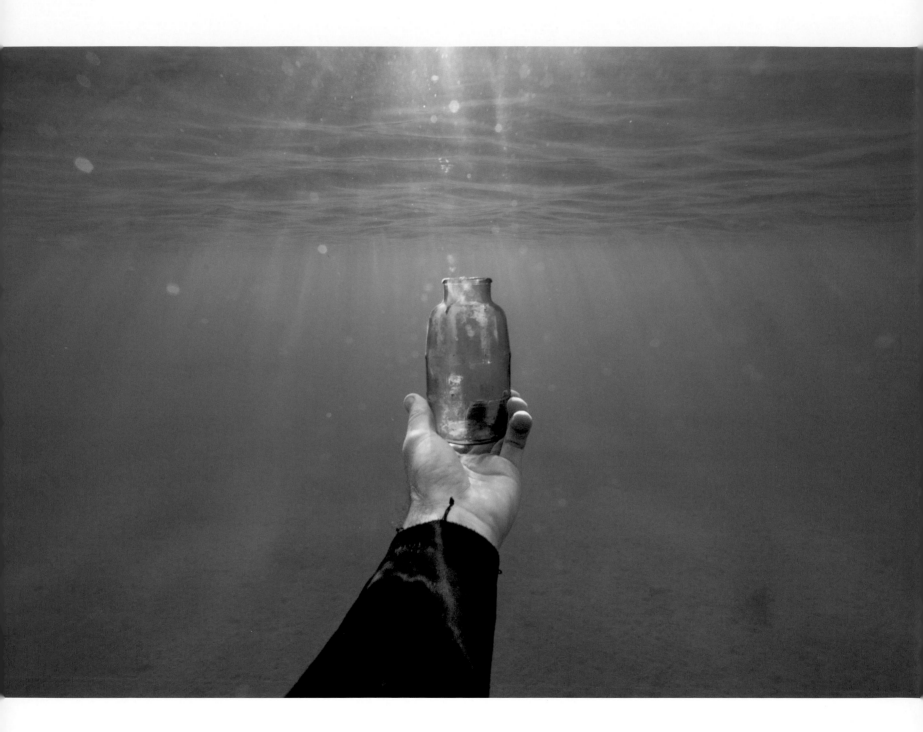

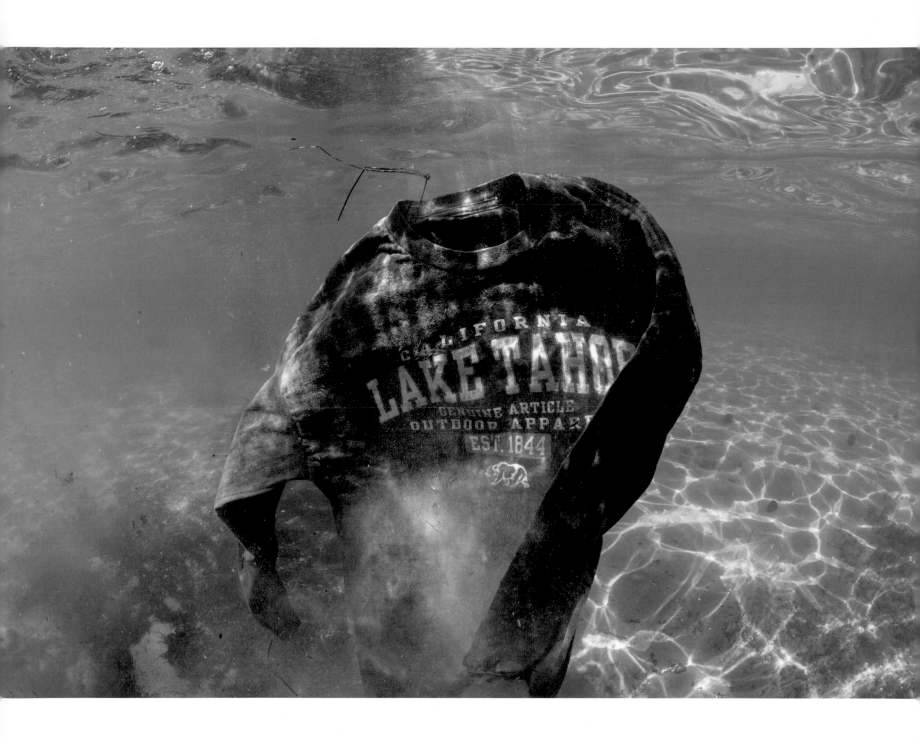

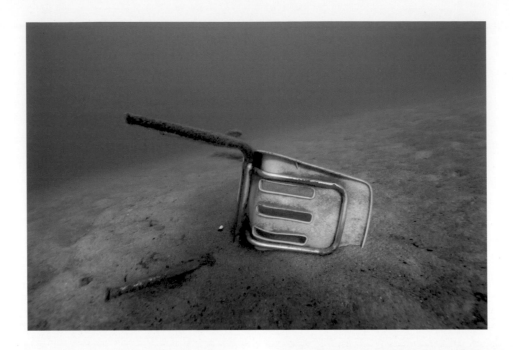

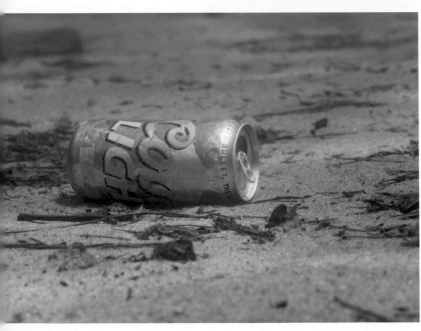

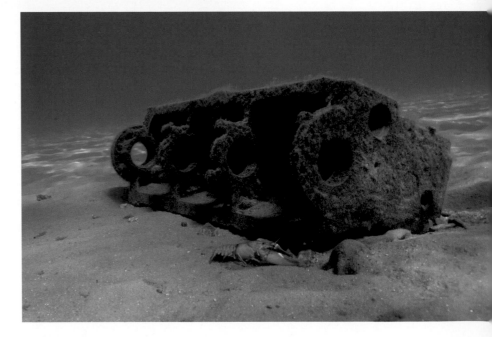

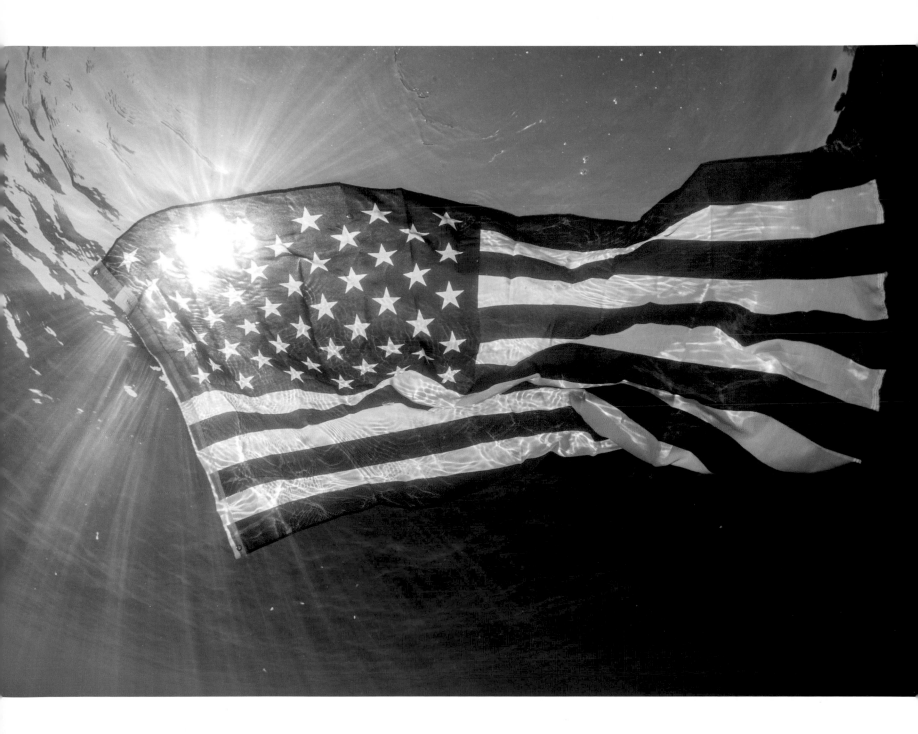

CLARITY

THE FIGHT TO SAVE LAKE TAHOE

Anyone who's spent enough time on, near, or in the water can recognize the seasonal changes that affect the water color, temperature, algae, and lake level. It's common for the clarity to drop in the spring and algae to bloom. We feel the water warm through the summer and suddenly drop as the nights grow cold in the fall.

These changes are normal and have likely been cycling through the Basin for millennia. But drastic changes such as thick blankets of algae suddenly appearing, new species growing abundantly, and staggeringly warm waters are alarming. The visible loss of clarity in spring 2017 was especially worrisome. Due to the fog of fine particulate and the shift in color from turquoise to olivish green blue, some underwater areas were unrecognizable.

Seeing the drop in clarity firsthand gave me a huge respect for all the agencies, nonprofits, and individuals who are working hard to protect Lake Tahoe. While working on this project, I was fortunate to participate in everything from algae sampling to an organized underwater cleanup. I learned about the catchment basins that stop and filter runoff before it enters the lake, and efforts to reduce invasive species before they spread to pristine areas.

The photos in this section are just a few of the common threats to the beautiful blue water. Signal crayfish, thick mats of algae, Eurasian watermilfoil, and murk are all characteristics of duck ponds. These conditions could make Tahoe indistinguishable from shallow lowland lakes. Luckily, we have many smart and diligent scientists, researchers, laborers, and everyday citizens who are willing to donate their time and energy to prevent this unfortunate future.

I want to give a special thanks to the League to Save Lake Tahoe. Their effort has already saved the area from several disastrous ideas. They continue to encourage residents, visitors, and governing agencies to implement strategies, policies, and everyday actions (ride your bike!) that will protect Tahoe's water. They've been supportive of this book from early on, and I hope it will inspire more people to donate to the League's campaign to Keep Tahoe Blue (www.keeptahoeblue.org) or do their small part to protect this national treasure.

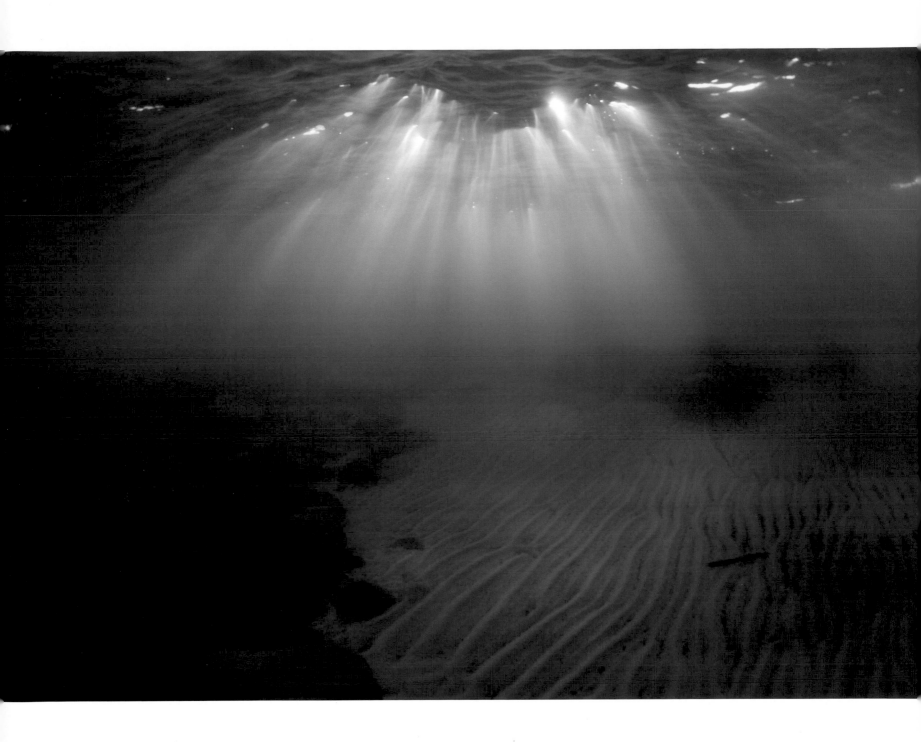

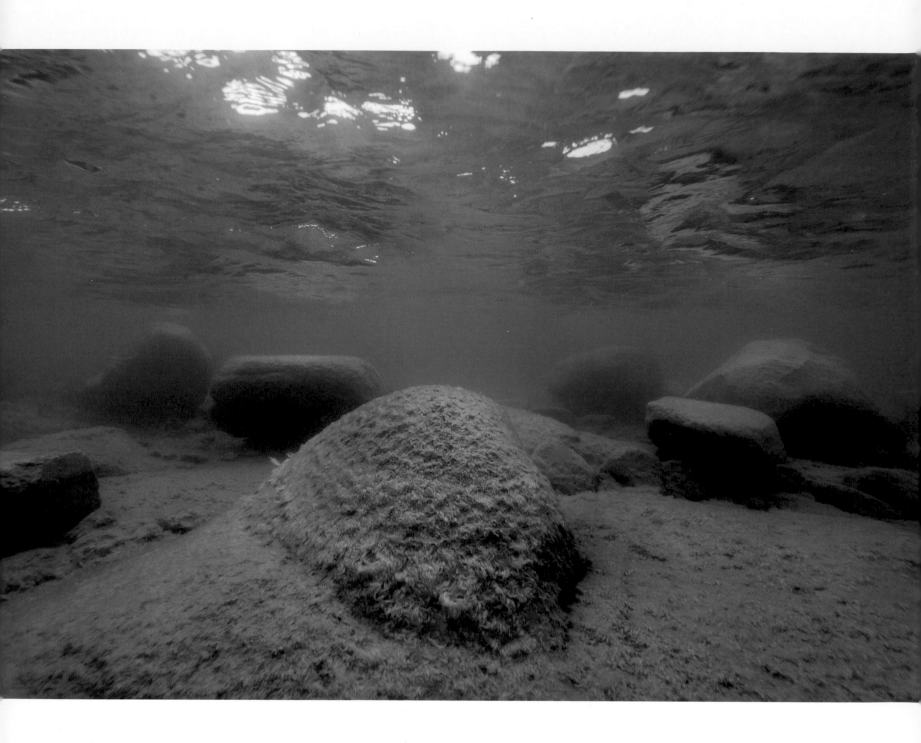

CLARITY

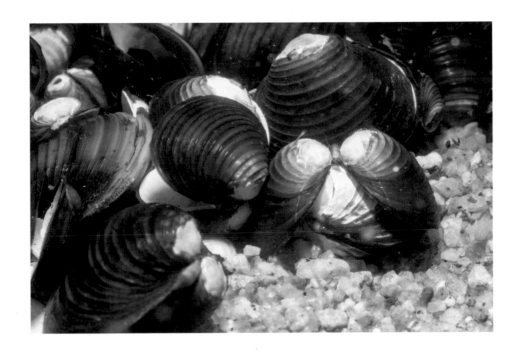

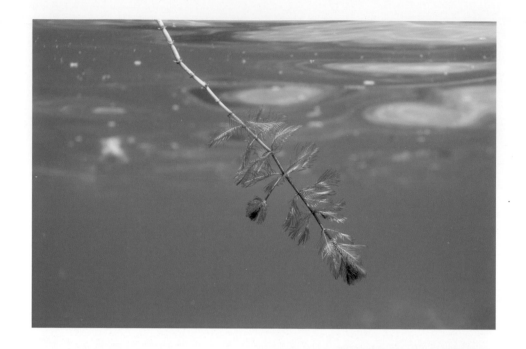

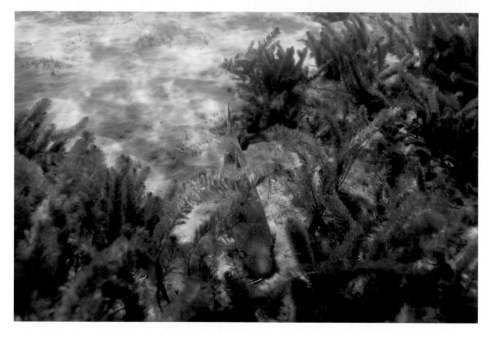

CLARITY

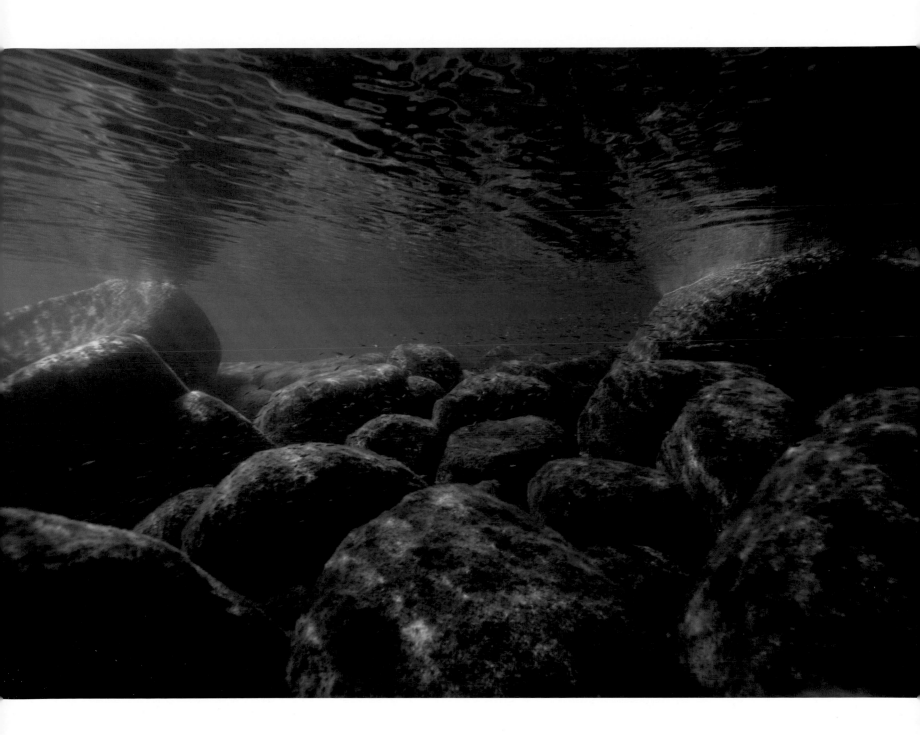

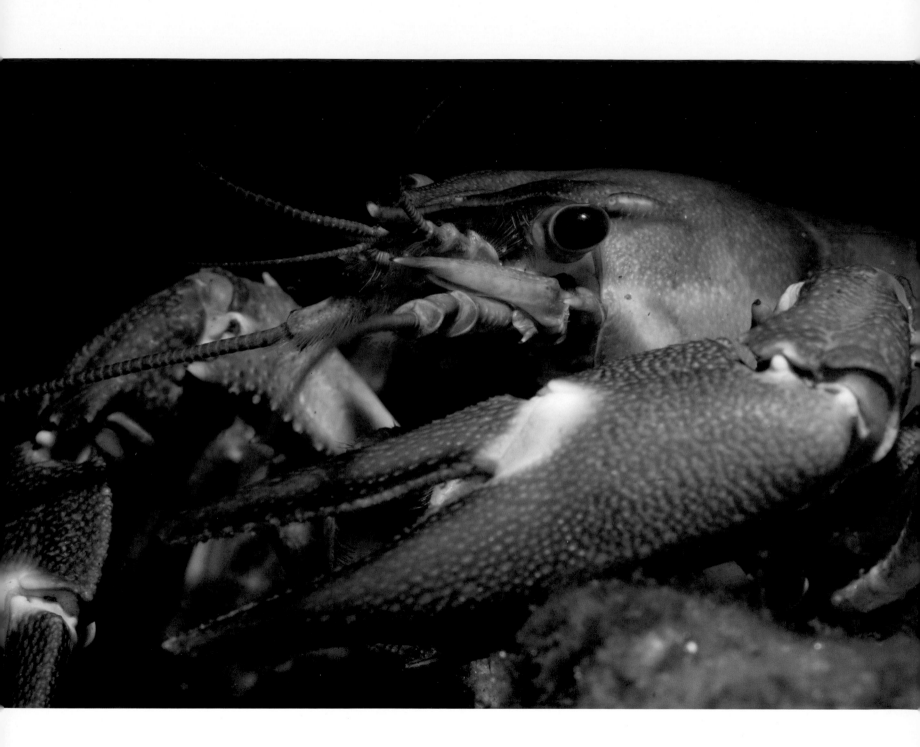

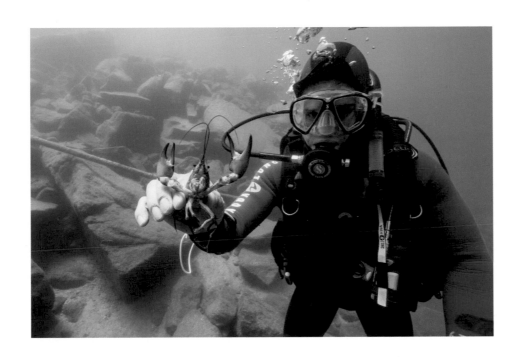

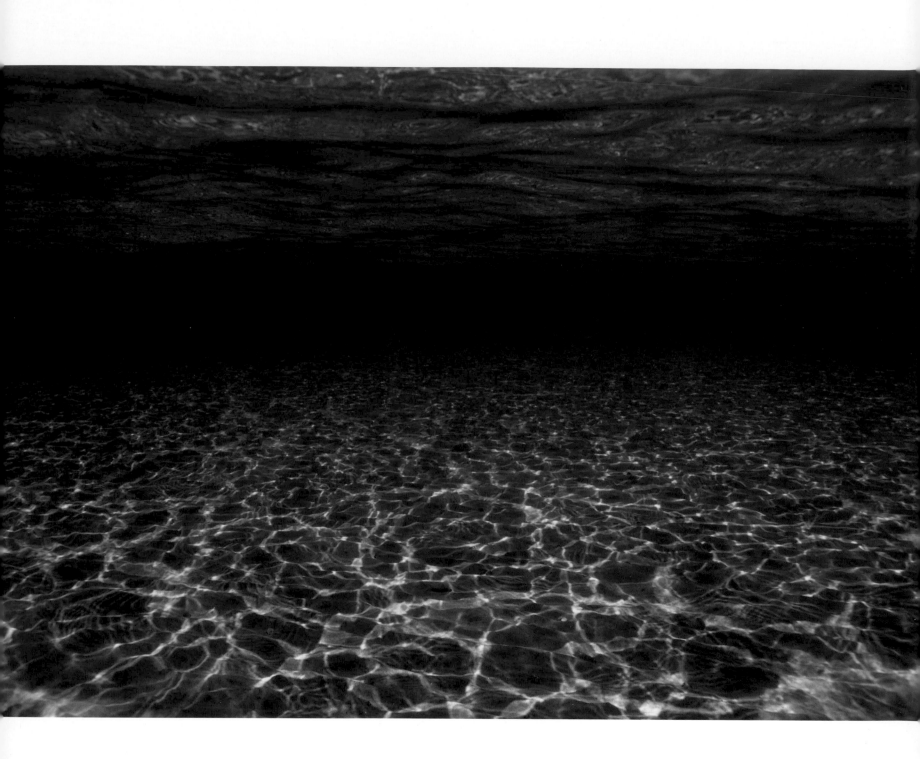

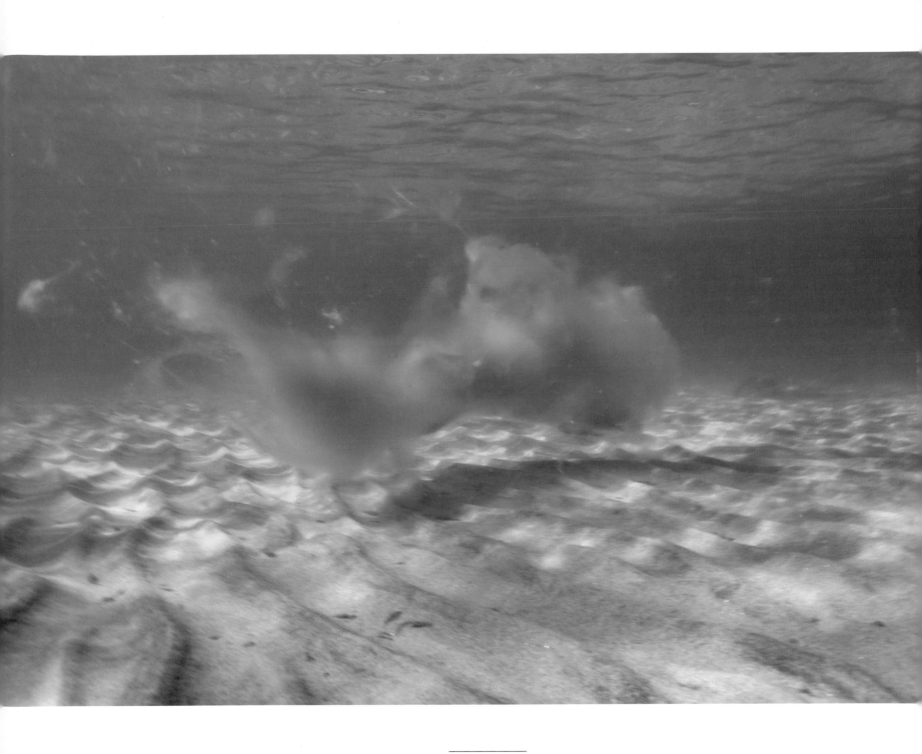

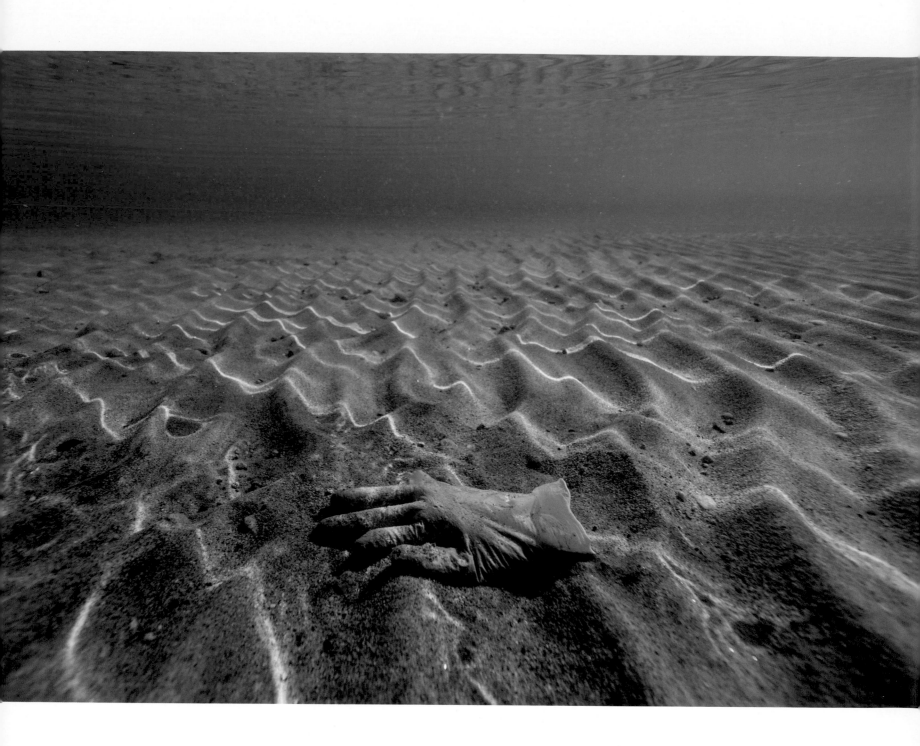

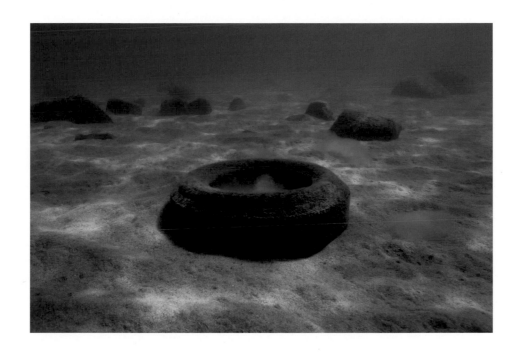

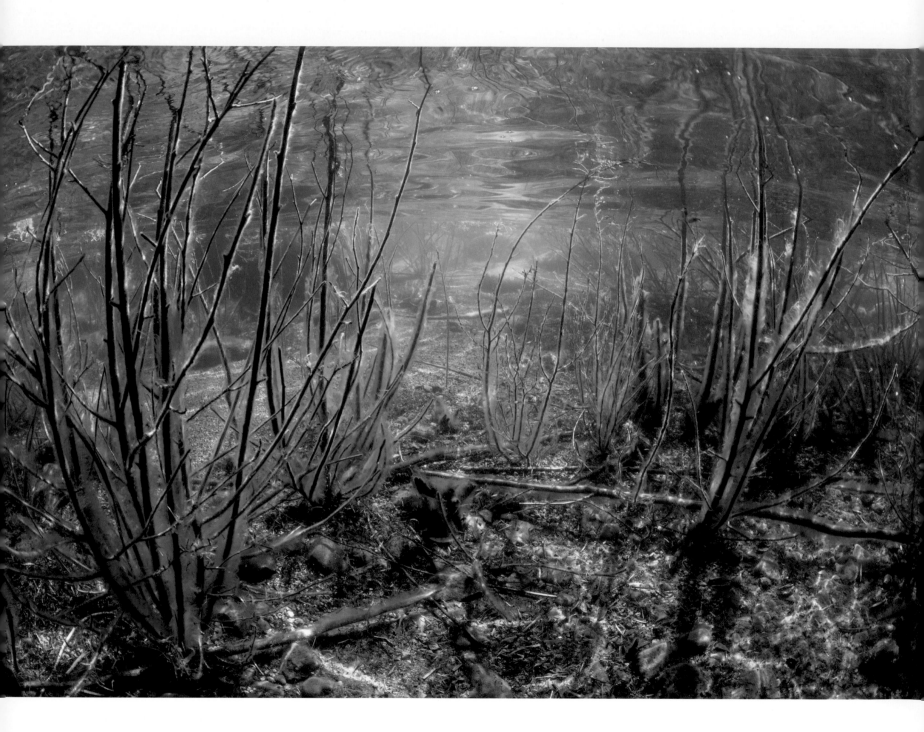

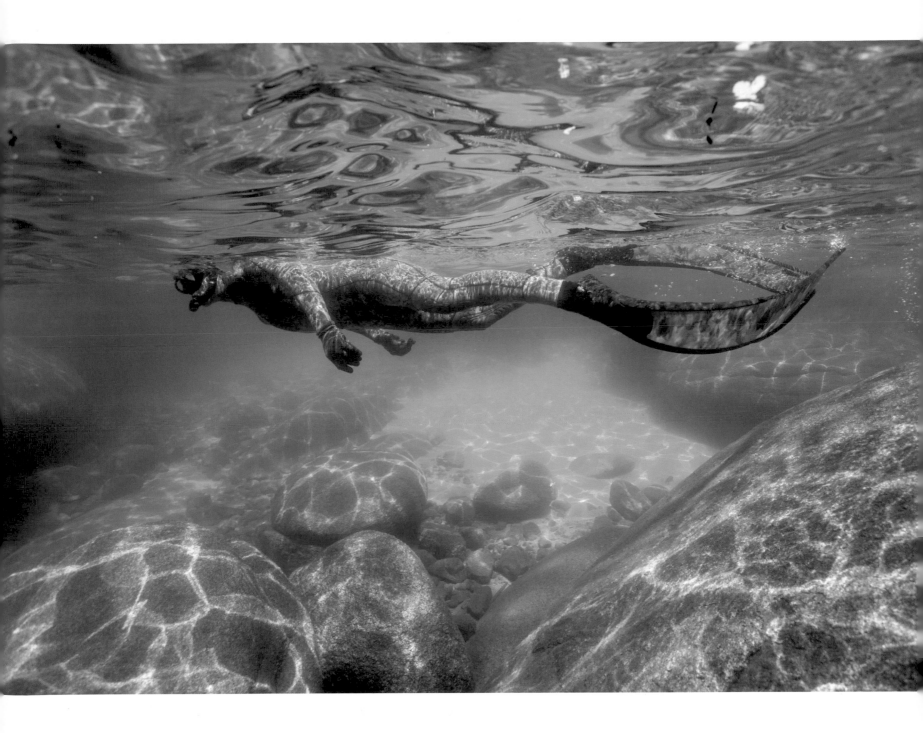

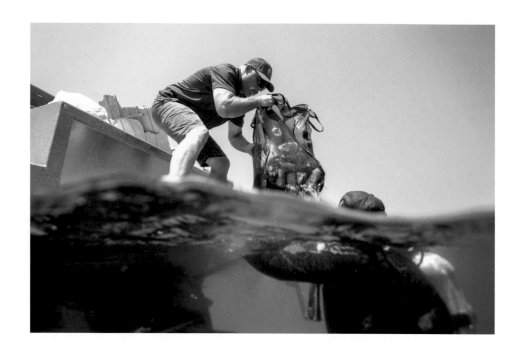

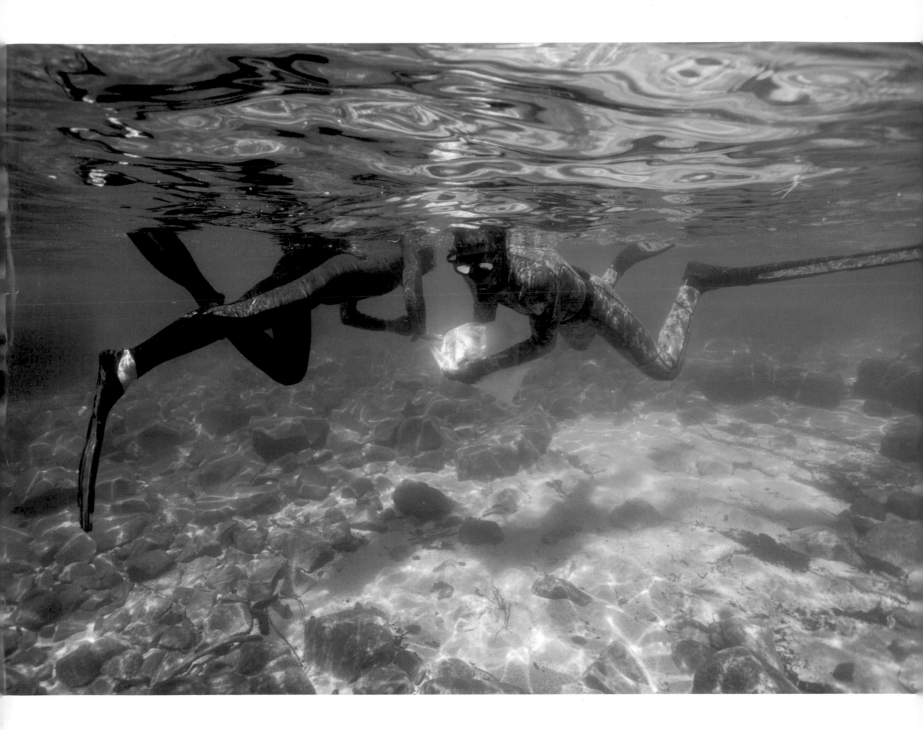

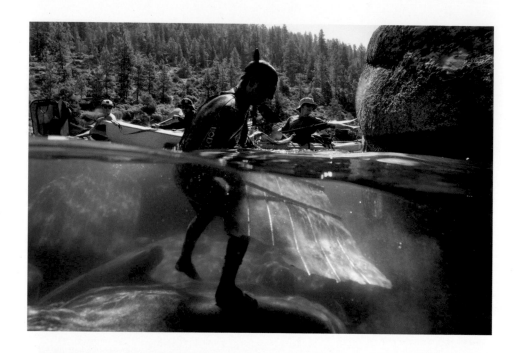

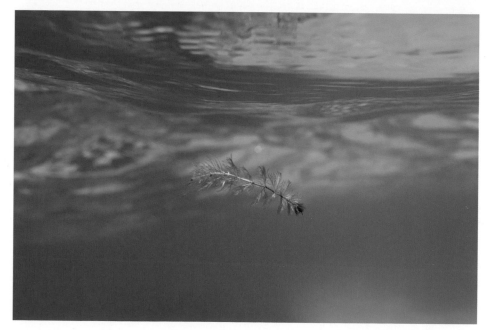